Kitchener Ontario Book 1 in Colour Photos, Saving Our History One Photo at a Time

Photography
by Barbara Raué
2013

Series Name:
Cruising Ontario

Book 42: Kitchener Book 1

Cover photo: 113 Water Street South

Series Name: Cruising Ontario
Saving Our History One Photo at a Time

Photos now in full colour
Check the Appendixes in the back of each book for
descriptions of architectural terms and building styles

Book 33: Southampton
Book 34: Jarvis
Book 35: Hagersville
Book 37: Simcoe
Book 38: Cambridge Part 1 – Galt Book 1
Book 39: Cambridge Part 1 – Galt Book 2
Book 40: Cambridge Part 2 – Preston
Book 41: Cambridge Part 3 – Hespeler
Book 42: Kitchener Book 1
Book 43: Kitchener Book 2
Book 46: Shelburne
Book 50: Orangeville Beginnings
Book 51: Orangeville on Broadway

Other Books by Barbara Raue

Coins of Gold

Arrows, Indians and Love

The Life and Times of Barbara
Volume 1: Inventions That Have Enhanced My Life
Volume 2: Entertainment That I Have Enjoyed
Volume 3: East Coast Trips
Volume 4: Olympics Have Always Intrigued Me
Volume 5: Wonders of the World
Volume 6: Caribbean Cruises We Have Enjoyed
Volume 7: Animals
Volume 8: Storms and Other Major Disasters in My Lifetime
Volume 9: Wars, Terrorist Attacks and Major Disasters

The Cromwell Family Book

Visit Barbara's website to view all of her books
http://barbararaue.ericraue.com

Kitchener

Kitchener is located in Southwestern Ontario in the Grand River Valley. The settlement's first name, Sand Hills, is an accurate description of the higher points of the Waterloo Moraine which snakes its way through the region and holds a significant quantity of artesian wells from which the city derives most of its drinking water.

In 1784, the land that Kitchener was built upon was an area of 240,000 hectares of land given to the Six Nations by the British as a gift for their allegiance during the American Revolution. The Six Nations sold 38,000 hectares of this land to Loyalist Colonel Richard Beasley, land that was remote but of great interest to German Mennonite farming families from Pennsylvania. They wanted to live in an area that would allow them to practice their beliefs without persecution. The Mennonites purchased all of Beasley's unsold land creating 160 farm tracts. By 1800, the first buildings were built, and over the next decade several families made the difficult trip north to Sand Hills. One of these Mennonite families, arriving in 1807, was the Schneiders, whose restored 1816 home (the oldest building in the city) is now a museum located in the heart of Kitchener.

Much of the land, made up of moraines and swampland interspersed with rivers and streams was converted to farmland and roads. Apple trees were introduced to the region by John Eby in the 1830s, and several grist and sawmills were erected throughout the area. Schneider built the town's first road from his home to the corner of King Street and Queen Street (then known as Walper corner), $1000 was raised by the settlers to extend the road from Walper corner to Huether corner, where the Huether Brewery was built and the Huether Hotel now stands.

In 1833 the town was renamed Berlin. The extension of the Grand Trunk Railway from Sarnia to Toronto and through Berlin in July 1856 was a major boon to the community helping to improve industrialization in the area. Through the latter half of the 19th century and into the first decade of the 20th, the City of Berlin was a bustling industrial centre celebrating its German heritage. When World War I started, that heritage became the focus of considerable enmity from non-German residents, and resulted in the name being changed to Kitchener.

On September 17, 1981 the first-ever "blue box" recycling program in the world was launched in Kitchener. Today over 90% of Ontario households have access to recycling programs.

Kitchener's economic heritage is rooted in manufacturing. While the local economy's reliance on manufacturing has decreased in recent years, more than 20% of the labour force remains employed in the manufacturing sector.

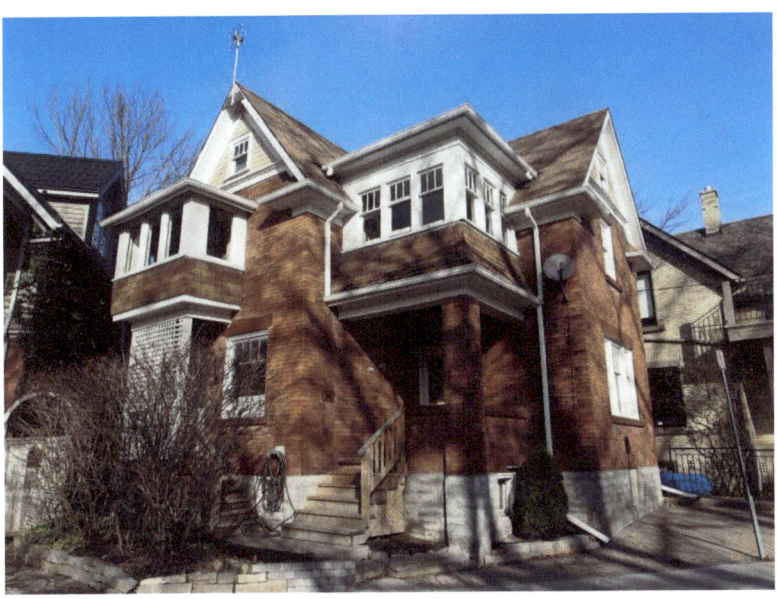

144 Water Street

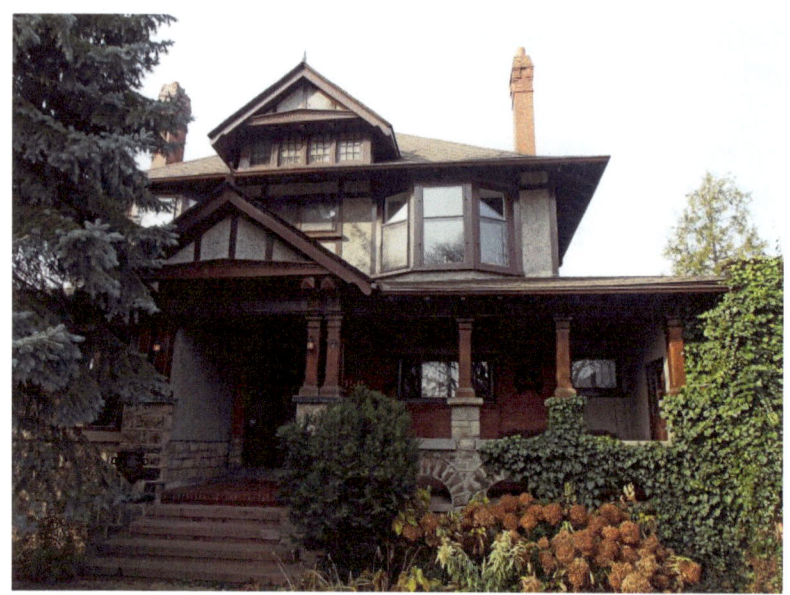

150 Water Street – Italianate style, pediment above door, dormer in attic, bay window on second floor

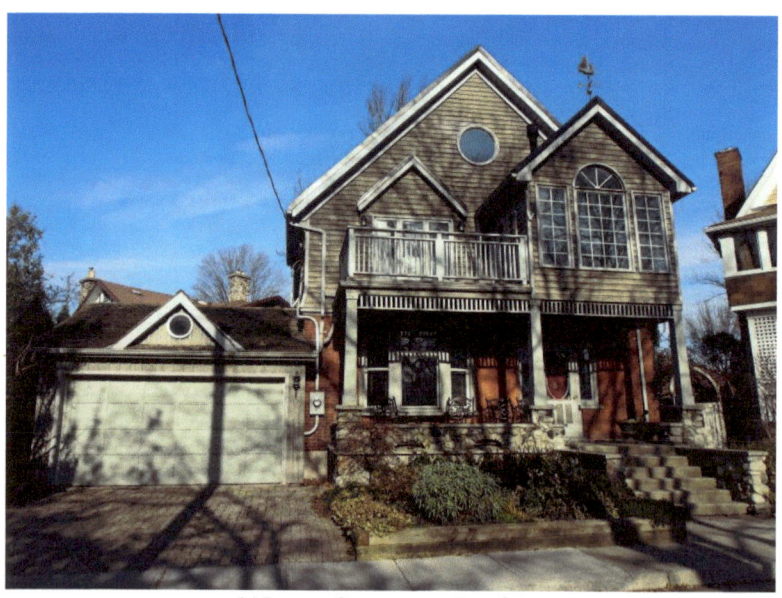

Water Street – Gothic

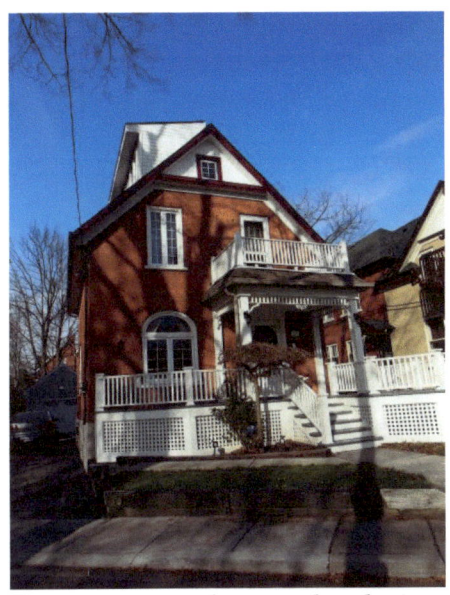

138 Water Street – Edwardian style, dormer in the attic

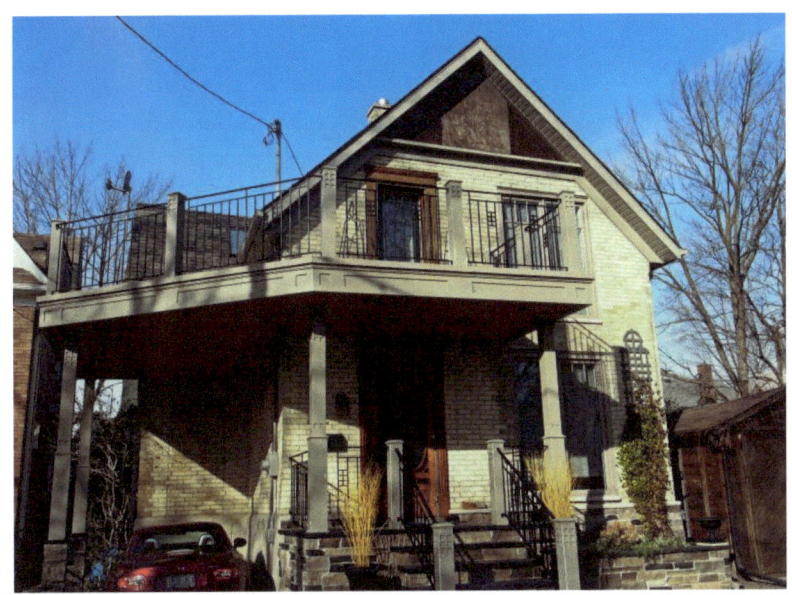

Water Street – yellow brick – Gothic, balcony on second level

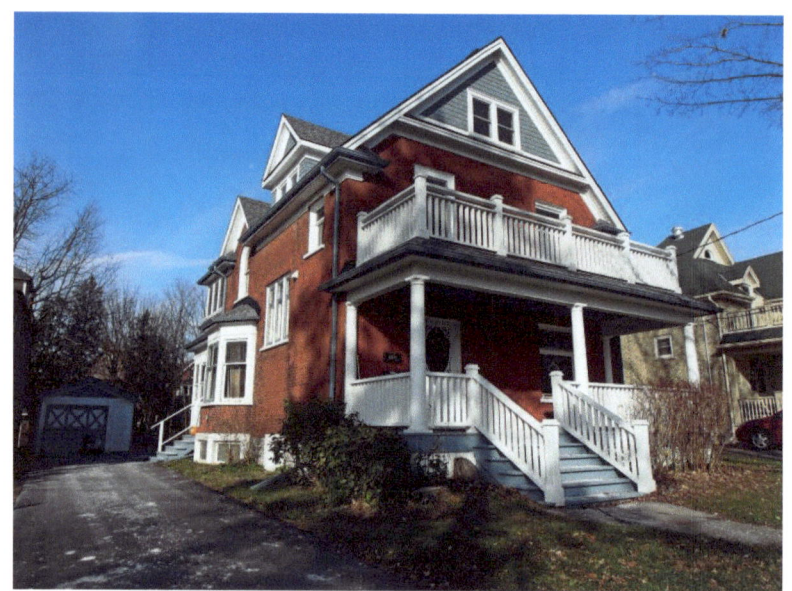

132 Water Street – Edwardian style with dormer in attic, balcony above the verandah

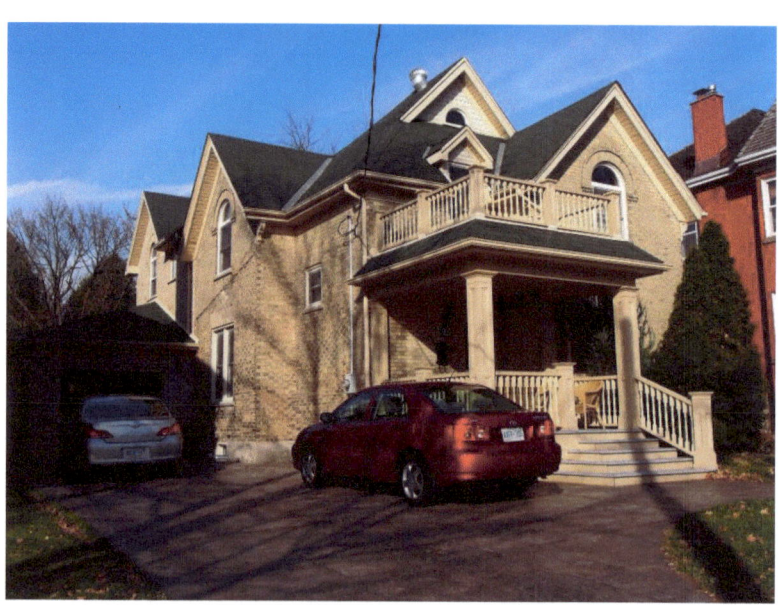

124 Water Street – Gothic

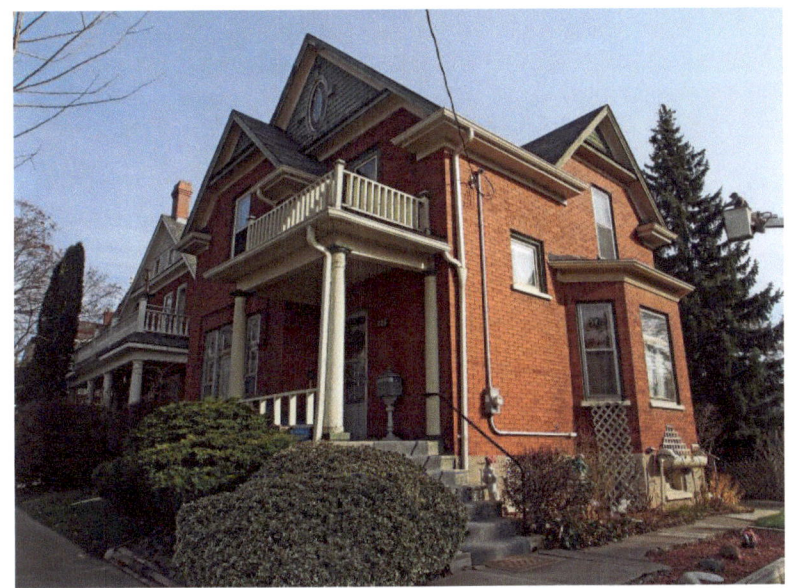

121 Water Street – Gothic Revival – red brick

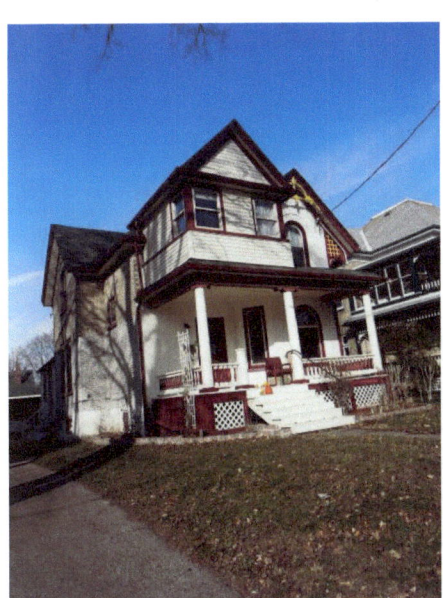

114 Water Street
- Gothic

84 Water Street
– arched window voussoirs

120 Water Street – Queen Anne style – two-storey tower with cone-shaped roof, Palladian window in dormer with cornice return on gable

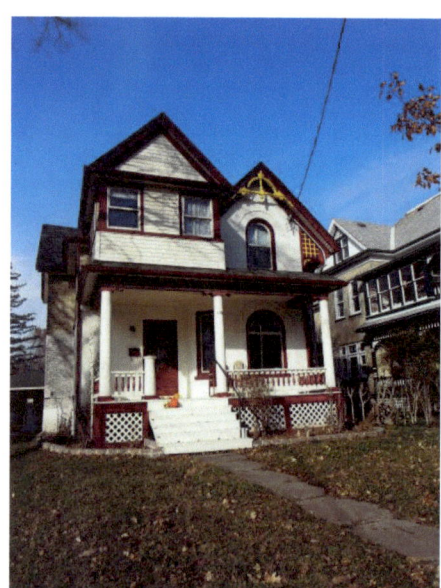

114 Water Street
Gothic

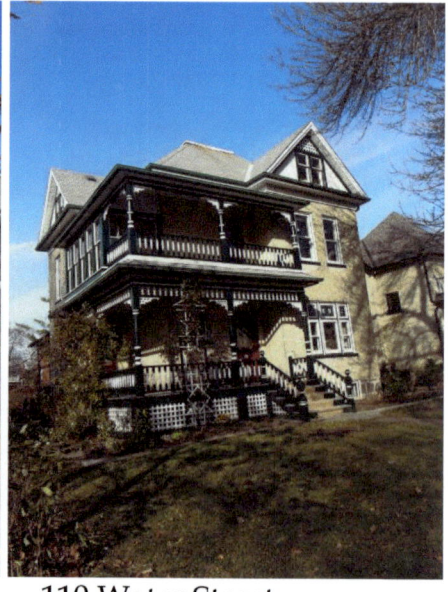

110 Water Street

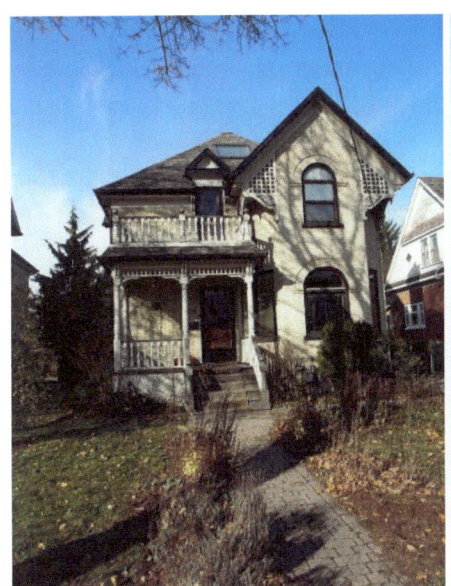

104 Water Street – Gothic Revival

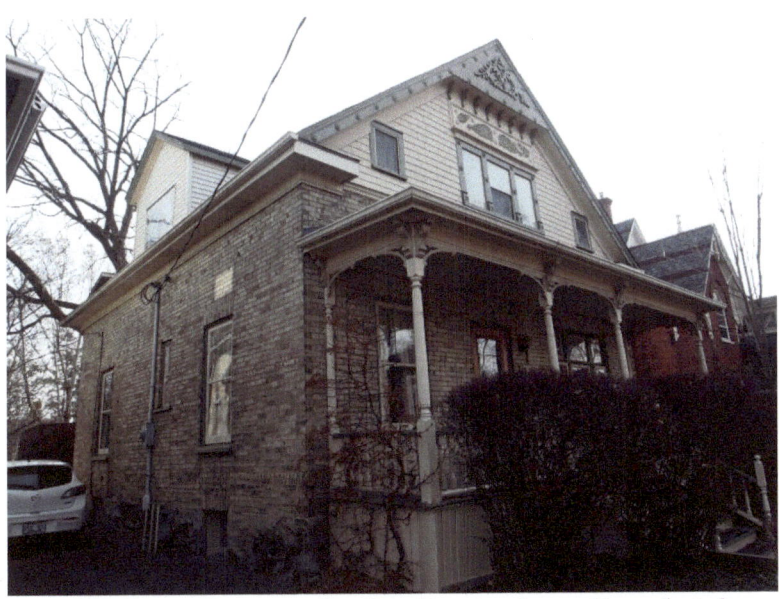

109 Water Street – Gothic Revival – yellow brick

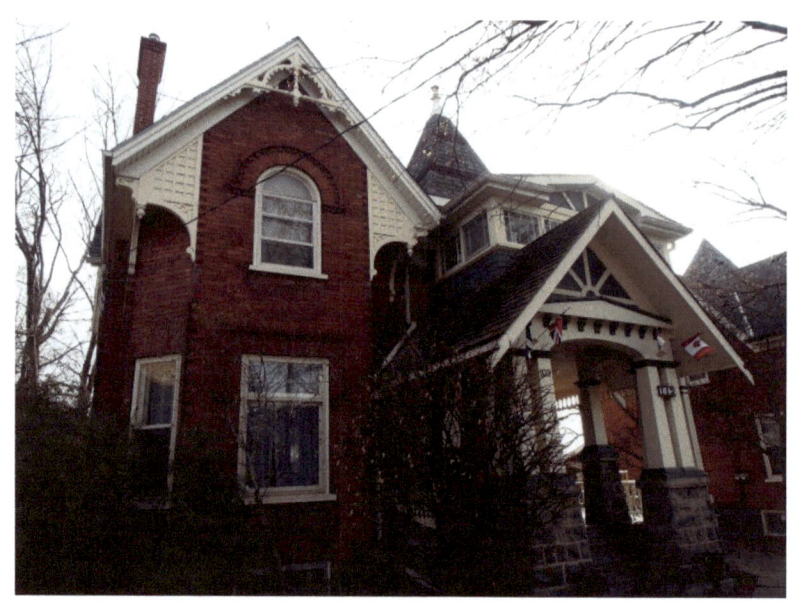

113 Water Street – Queen Anne style – Vergeboard trim, fretwork brackets, second-floor sun room,

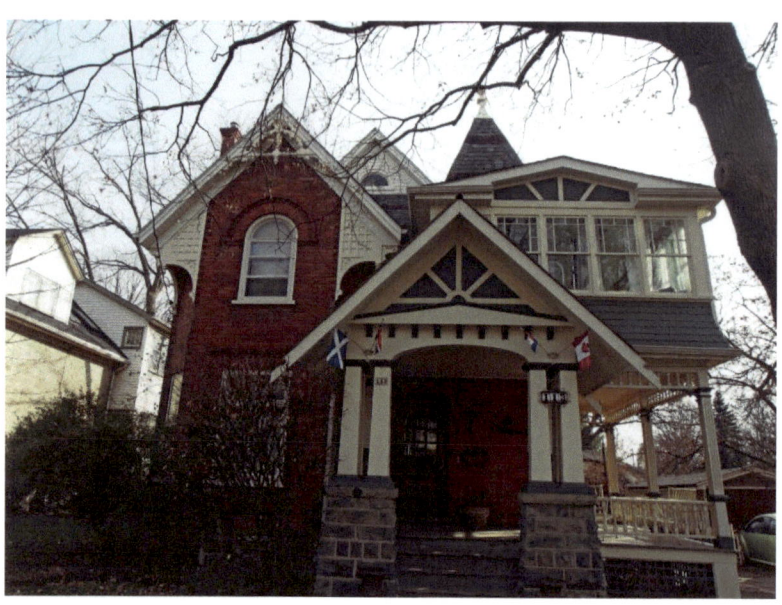

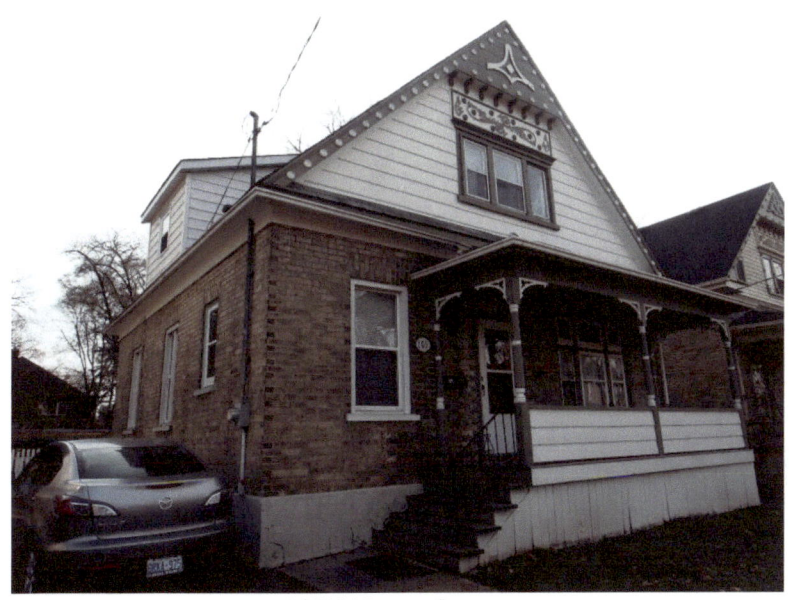

105 Water Street

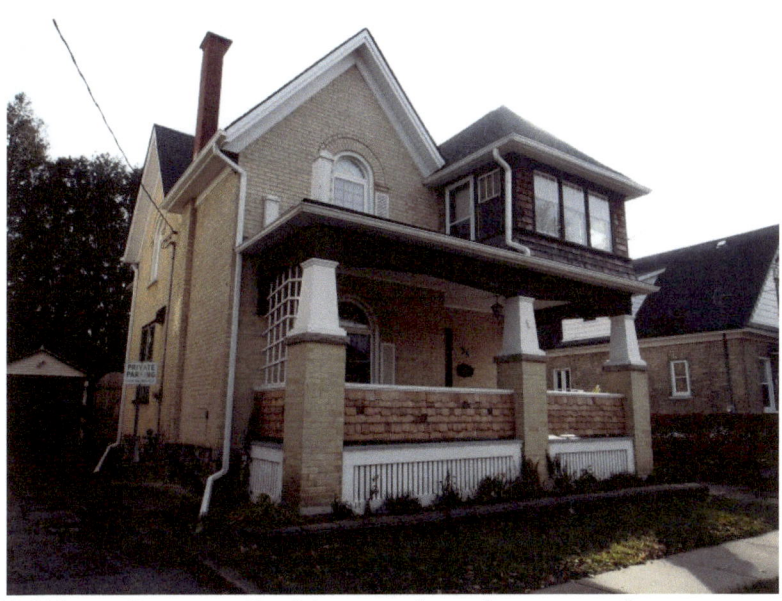

99 Water Street – Gothic – enclosed sun porch on second storey

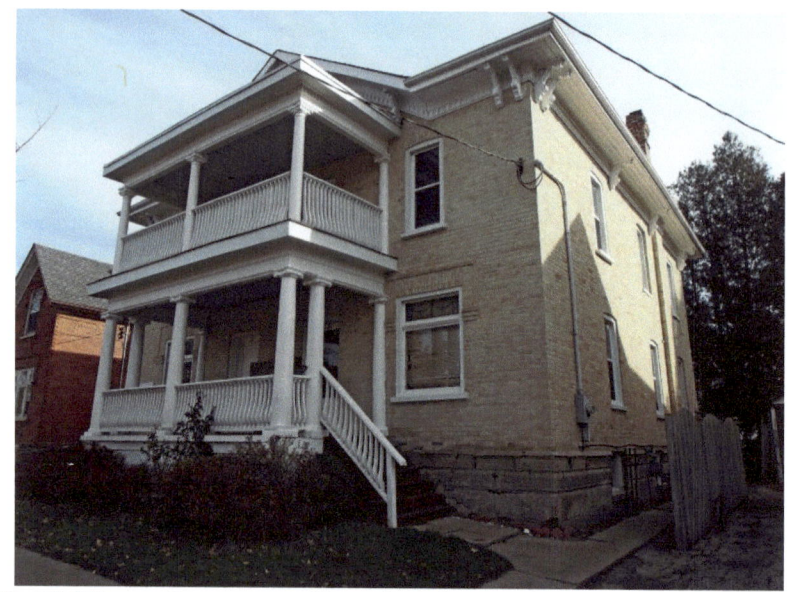

93, 95 Water Street – yellow brick – Italianate style, cornice brackets, verandah on each storey

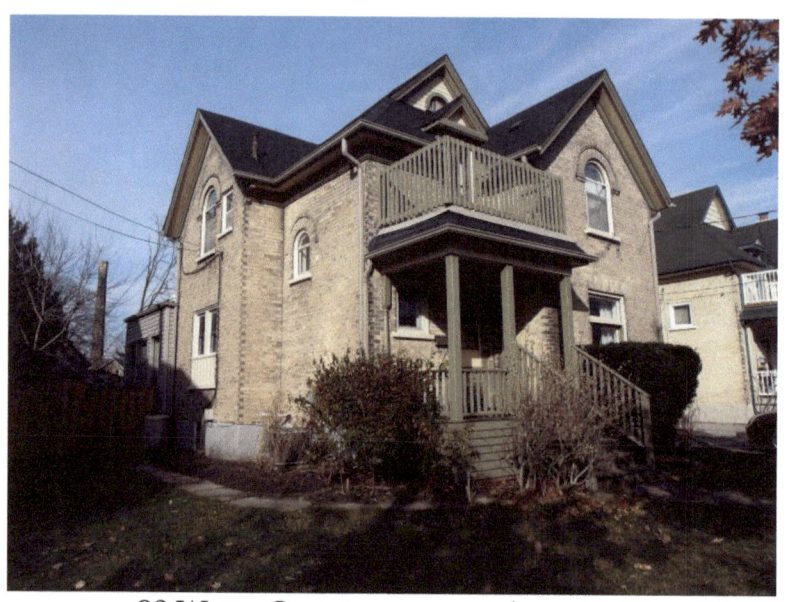

90 Water Street – same style as #124

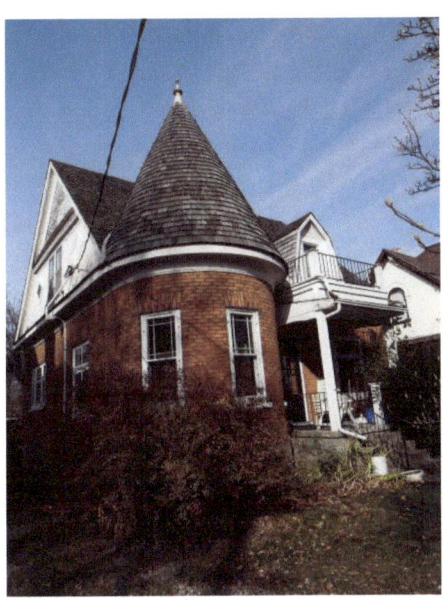

Water Street – Queen Anne eclectic style – one storey turret with cone-shaped roof, dormer in attic with balcony on second floor, bay window on the side

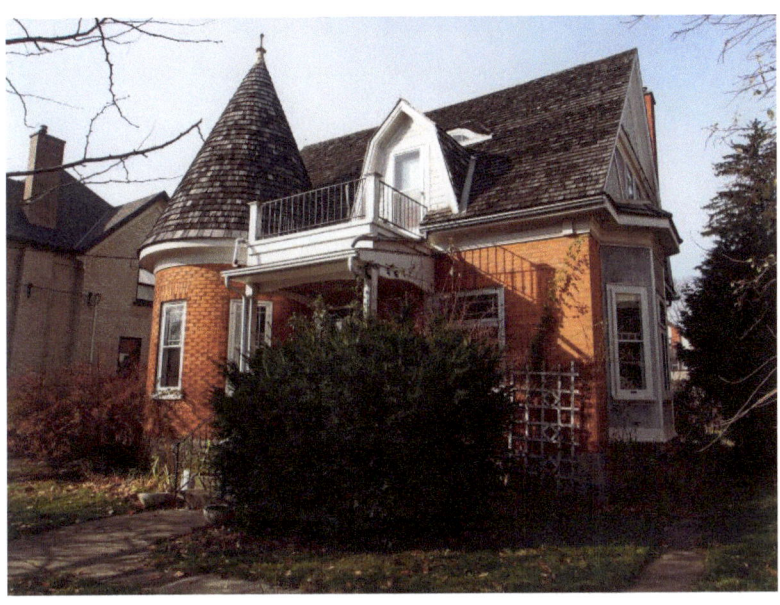

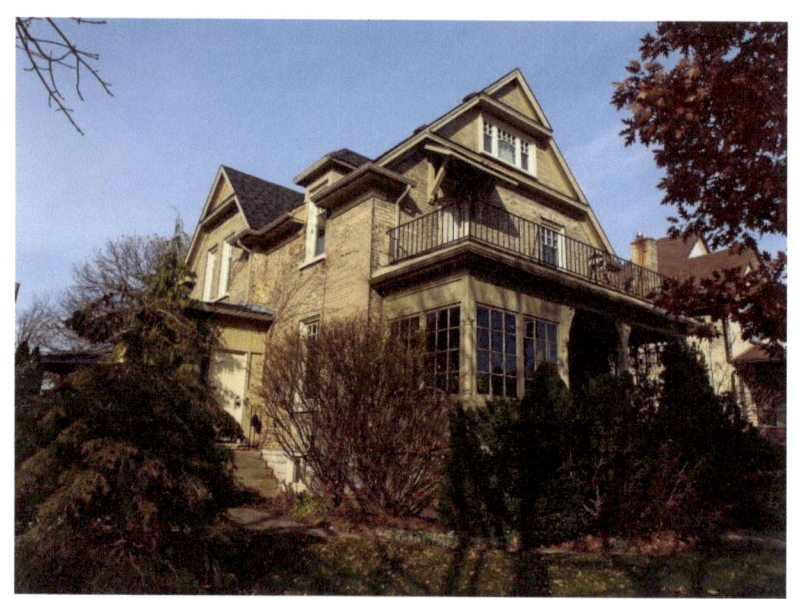
80 Water Street

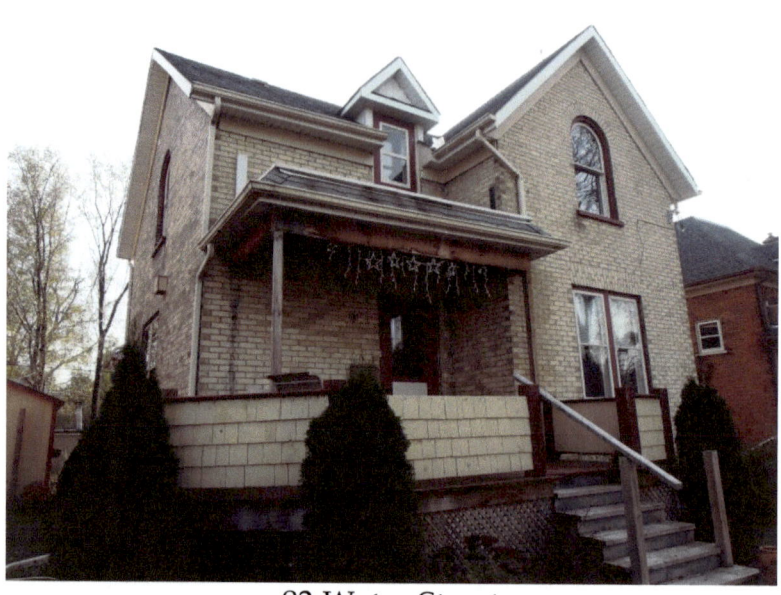
83 Water Street

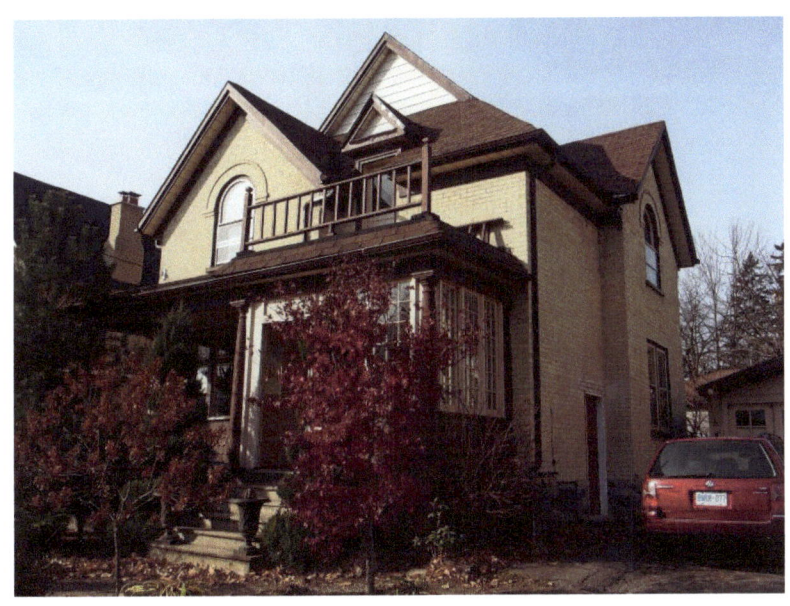

76 Water Street – yellow brick

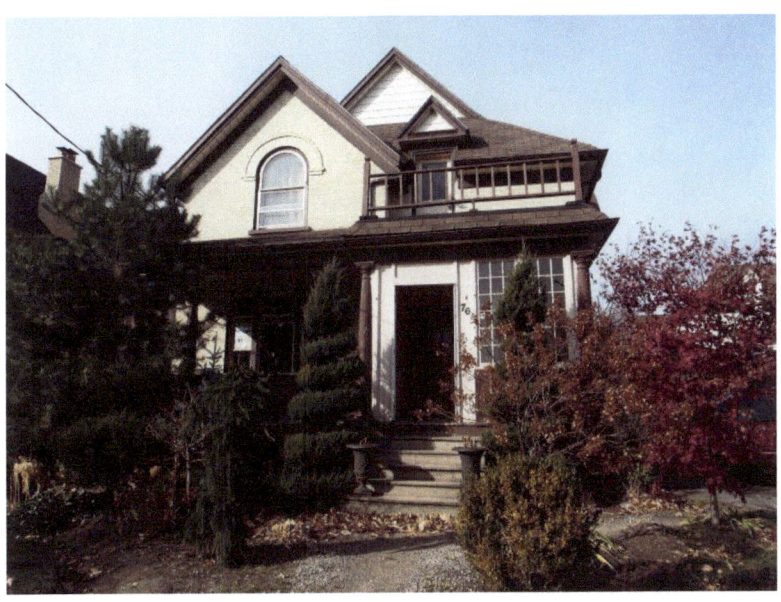

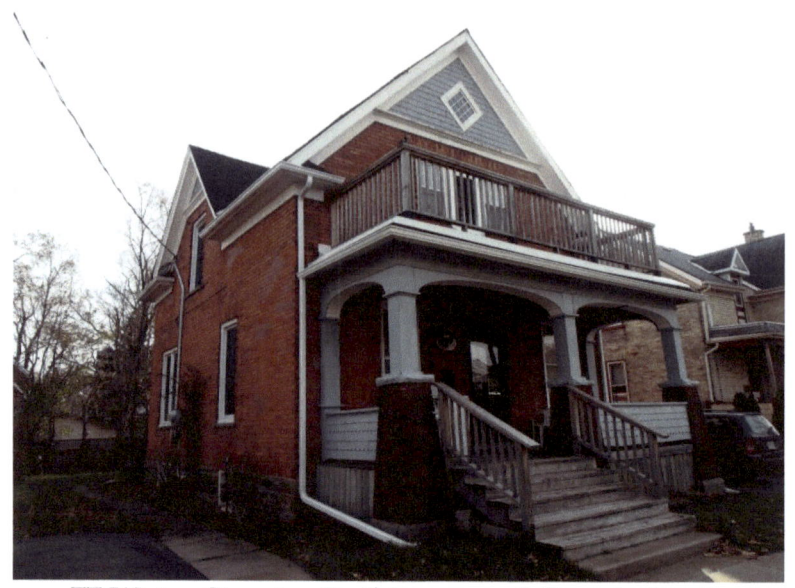

77 Water Street – Gothic, second-floor balcony

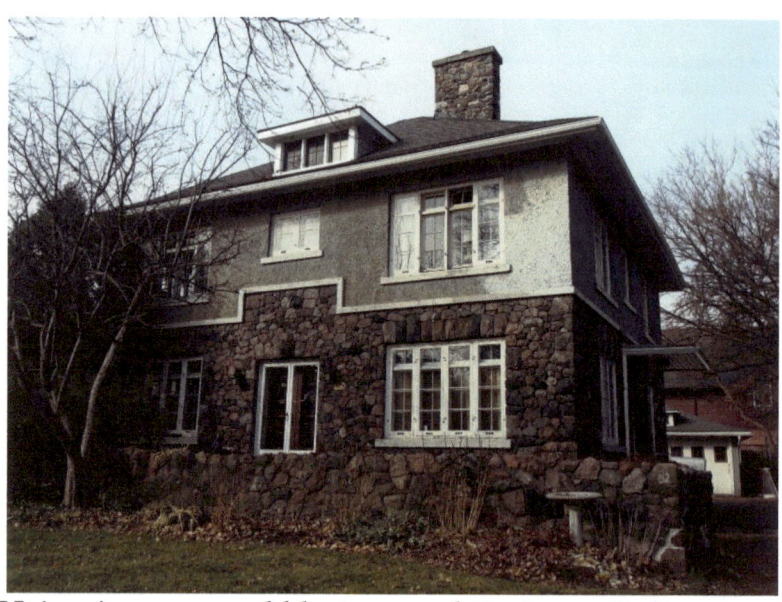

82 Heins Avenue – cobblestone architecture – Italianate style, dormer in attic

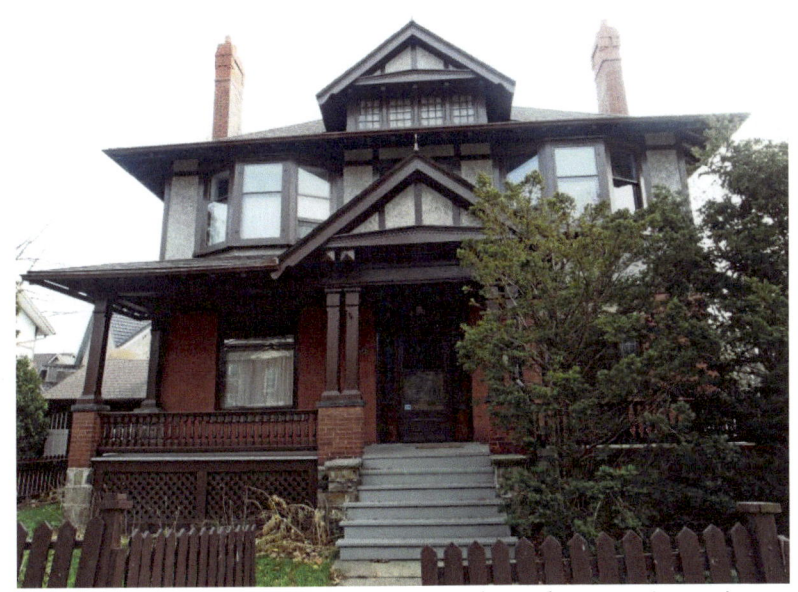

73 Heins Avenue – Tudor style – dormer in attic

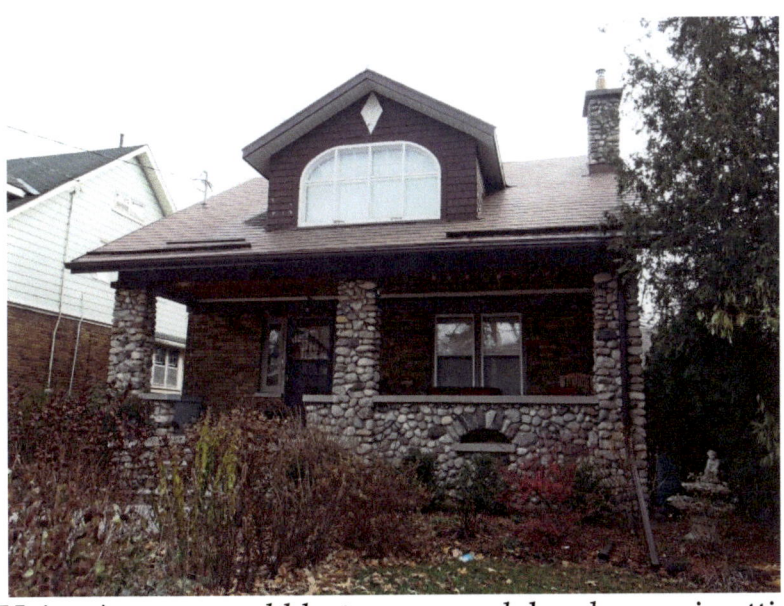

Heins Avenue – cobblestone verandah – dormer in attic

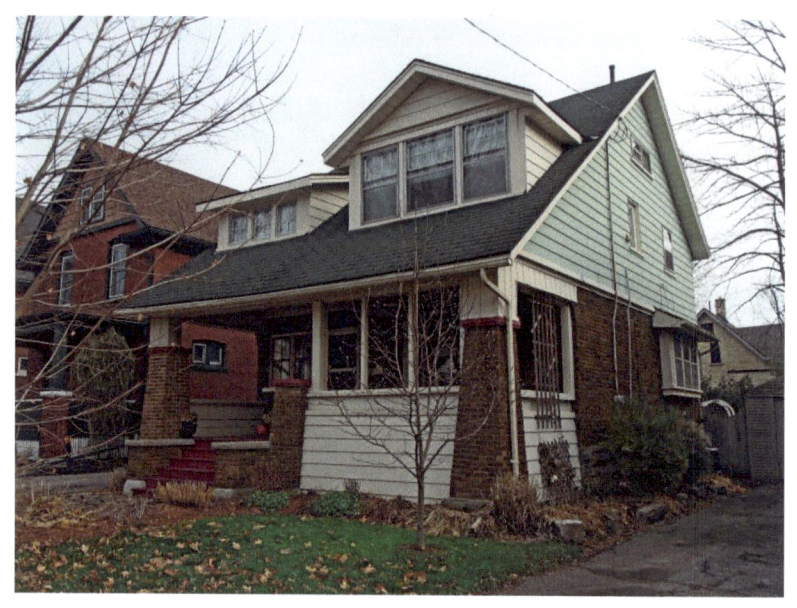

Heins Avenue

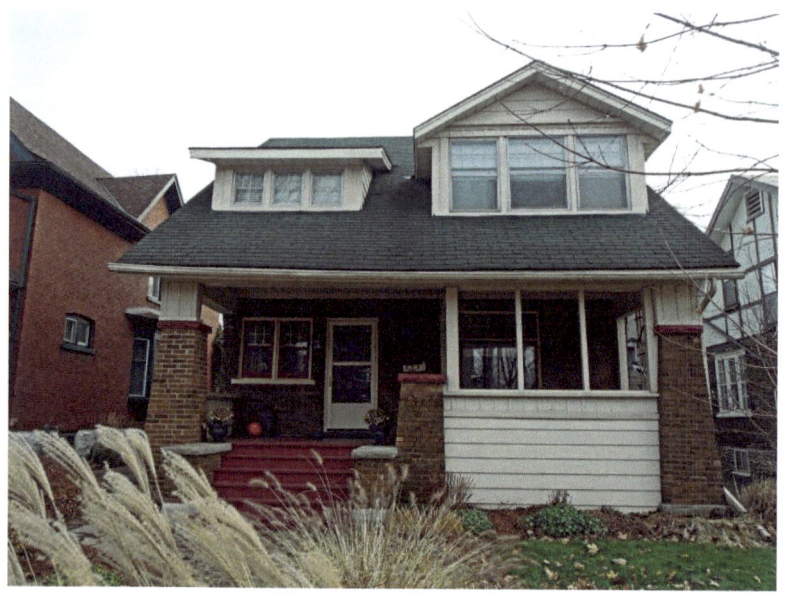

Dormers in attic

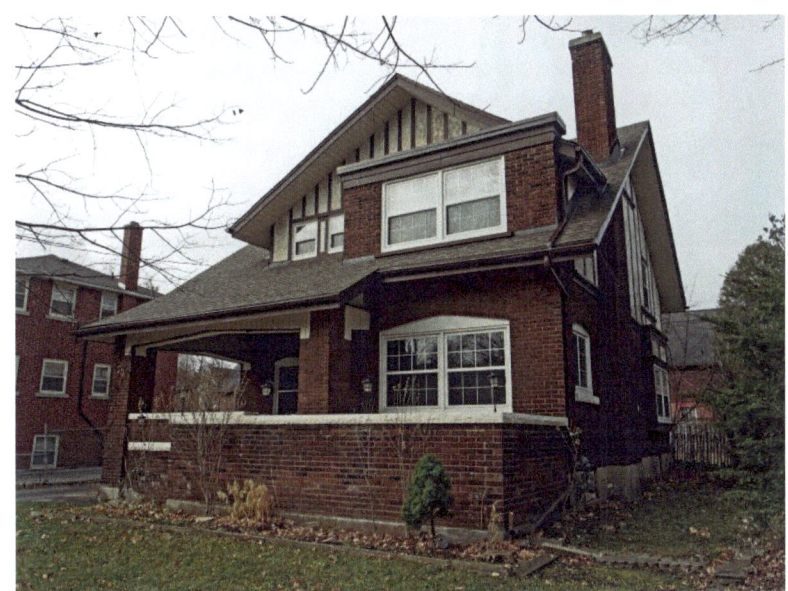

70 Heins Avenue – Tudor style

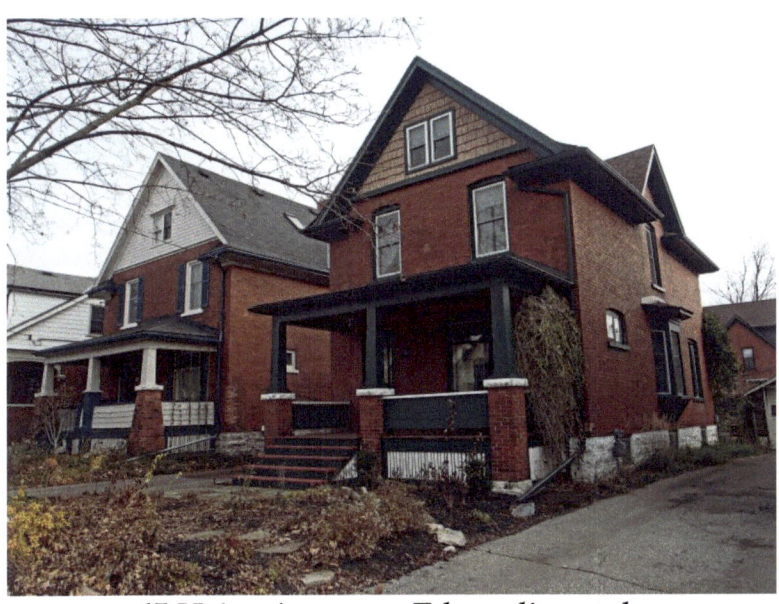

65 Heins Avenue – Edwardian style

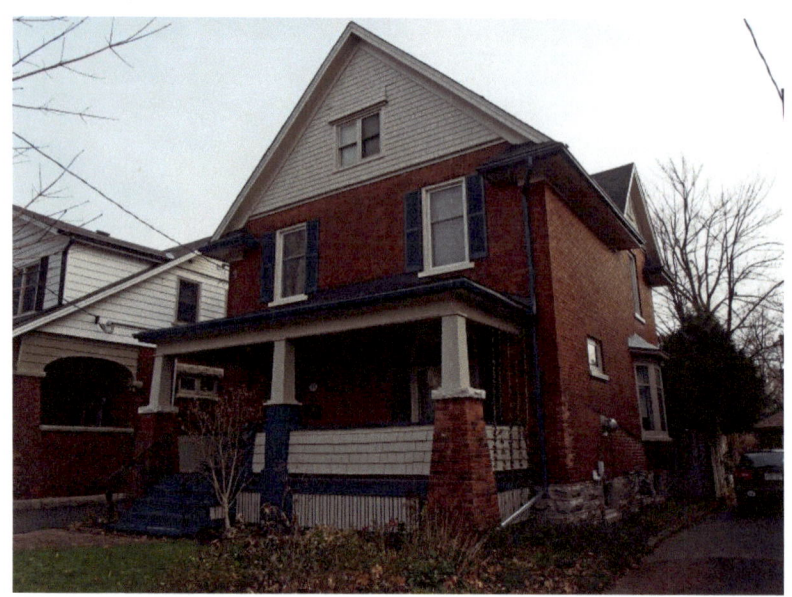

63 Heins Avenue – Edwardian style

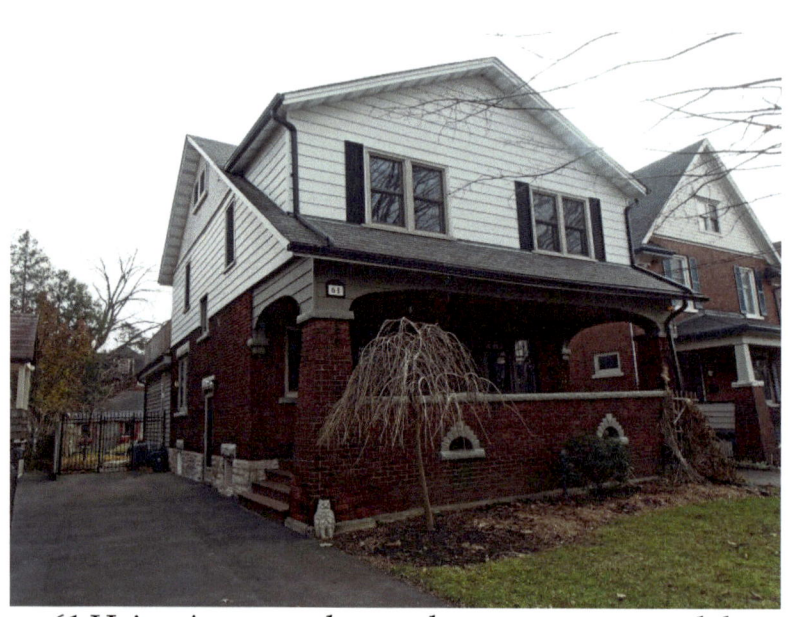

61 Heins Avenue – larger dormer over verandah

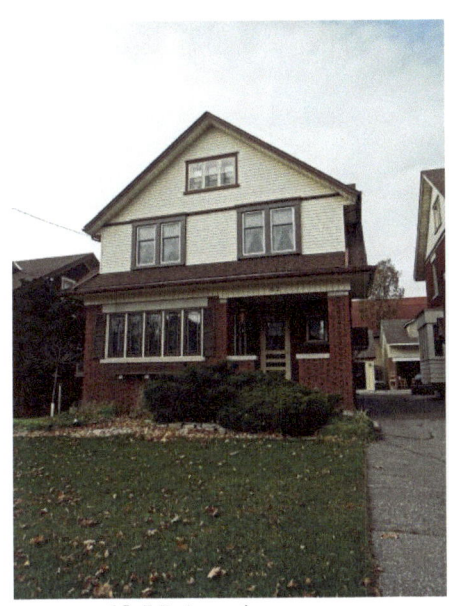

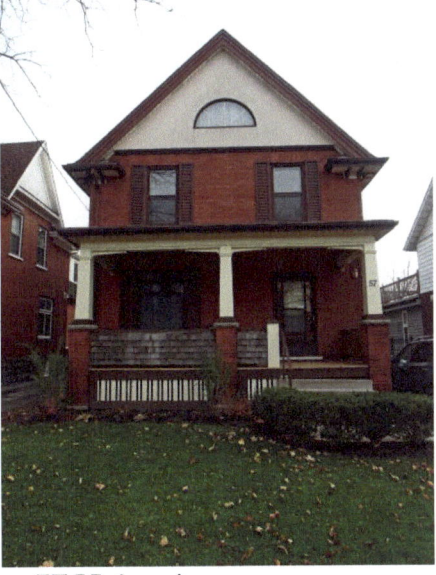

62 Heins Avenue

57 Heins Avenue
Edwardian style

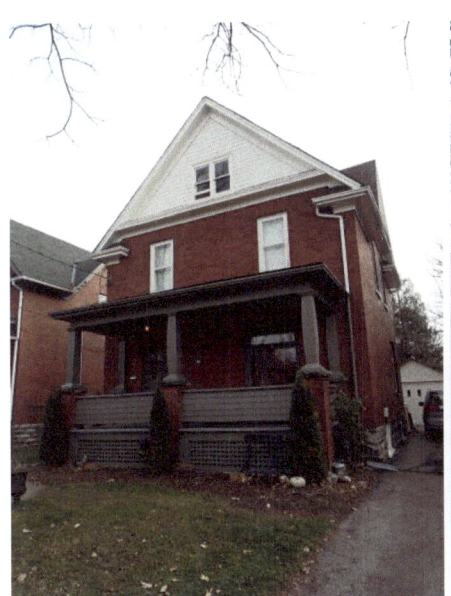

53 Heins Avenue
Edwardian style

41 Heins Avenue
Edwardian style

49 Heins Avenue - Edwardian style, Palladian window in gable

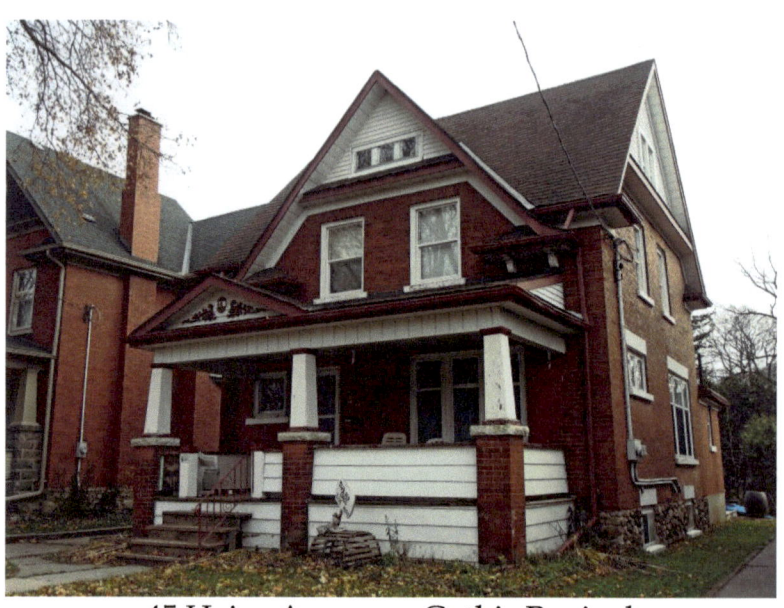

45 Heins Avenue – Gothic Revival

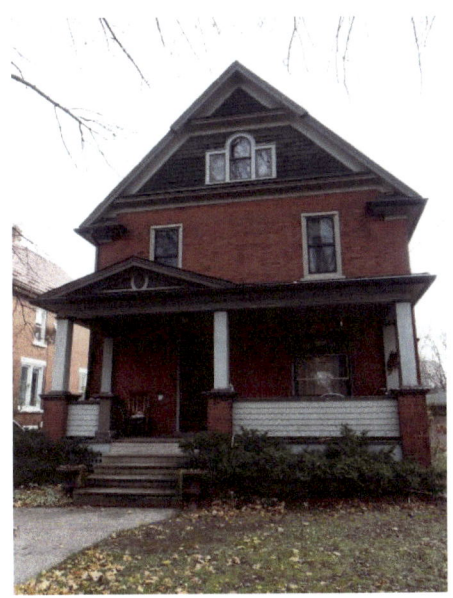

37 Heins Avenue
Edwardian style
Palladian window in gable

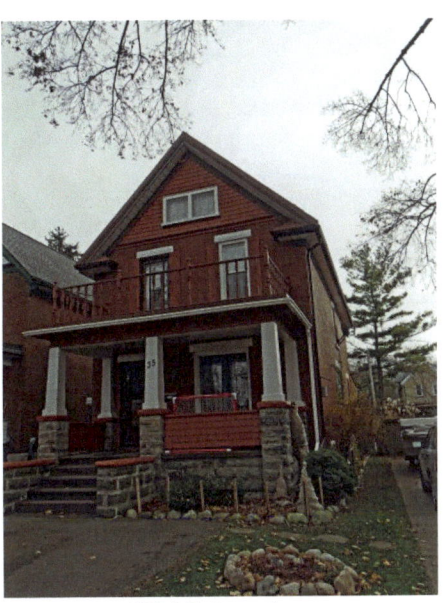

35 Heins Avenue
Edwardian style
cornice return on gable

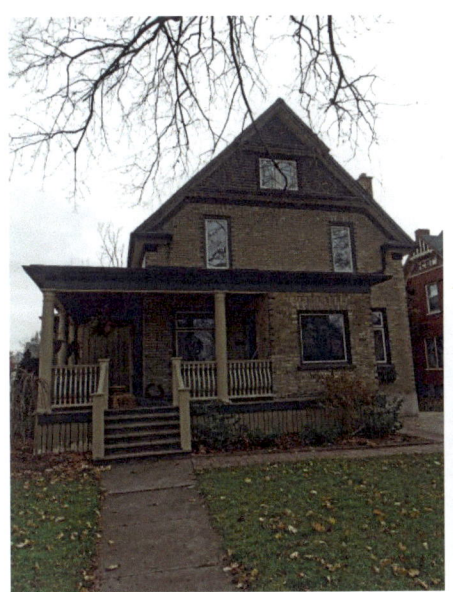

21 Heins Avenue
Edwardian style

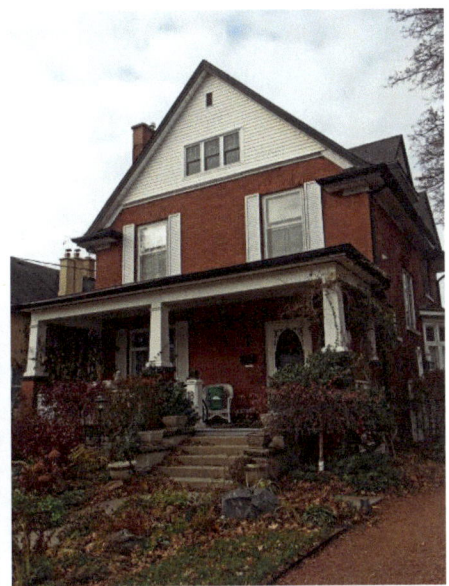

18 Heins Avenue

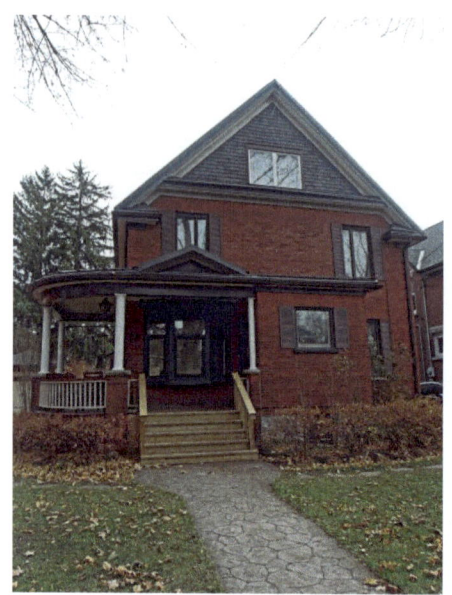 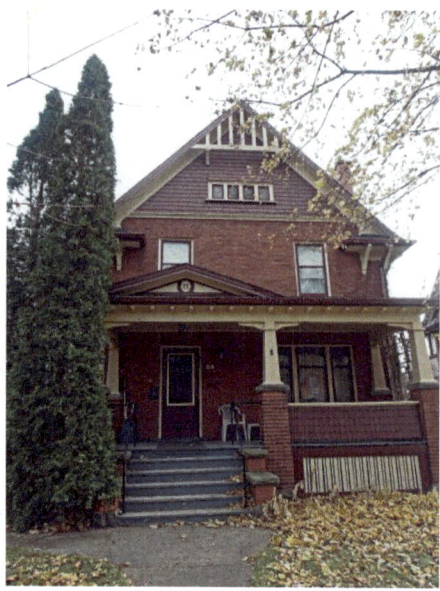

29 Heins Avenue 25 Heins Avenue
Wrap-around verandah Edwardian style, pediment above door

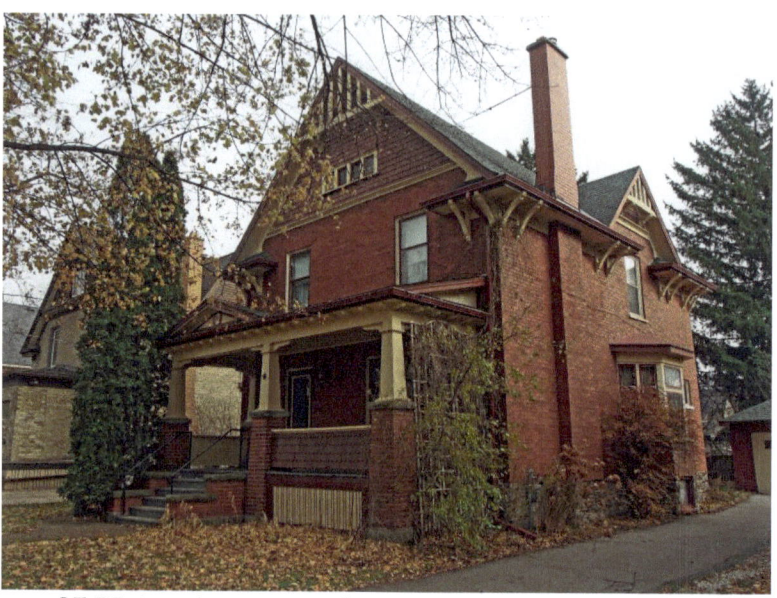

25 Heins Avenue – decorative cornice brackets

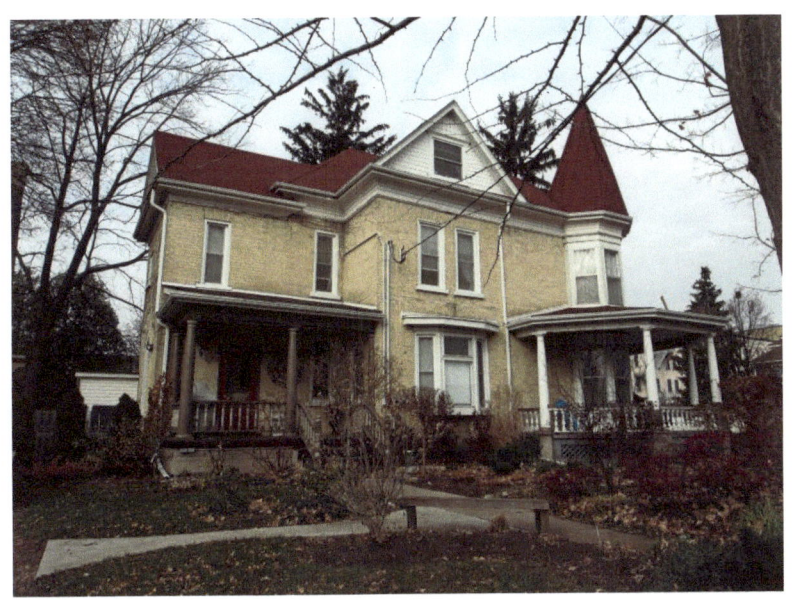

Heins Avenue – Queen Anne style, turret

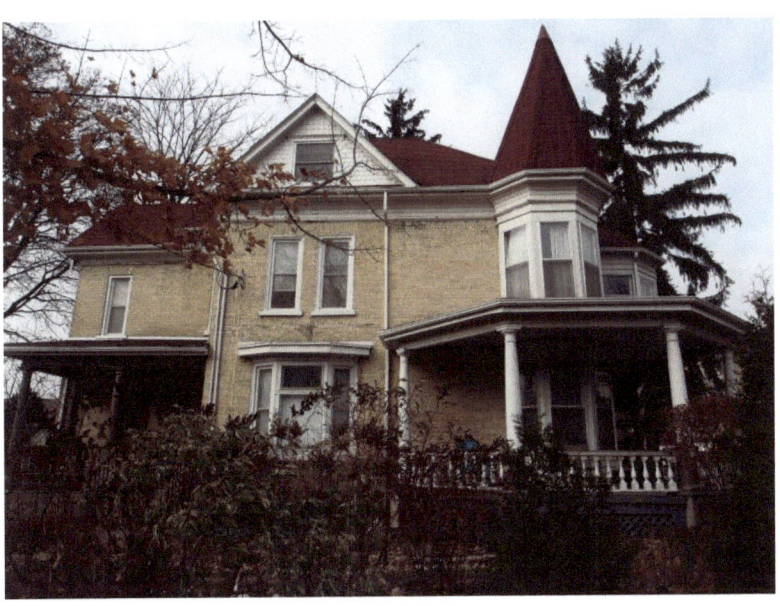

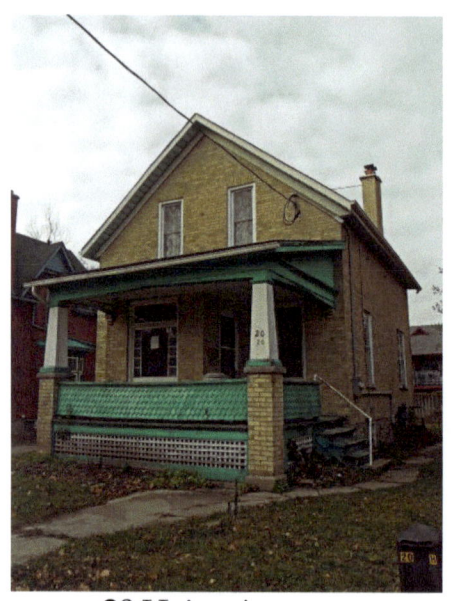

20 Heins Avenue
Gothic – yellow brick

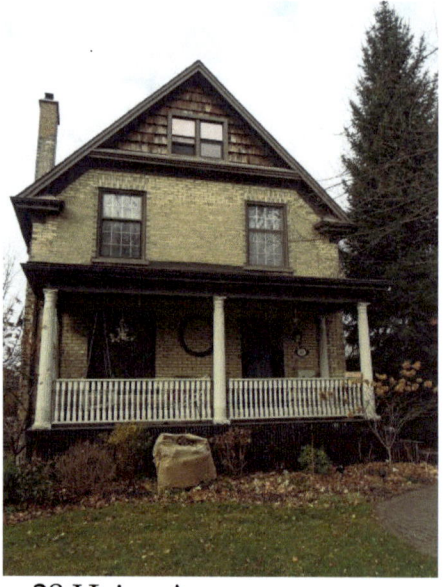

28 Heins Avenue
Edwardian – yellow brick

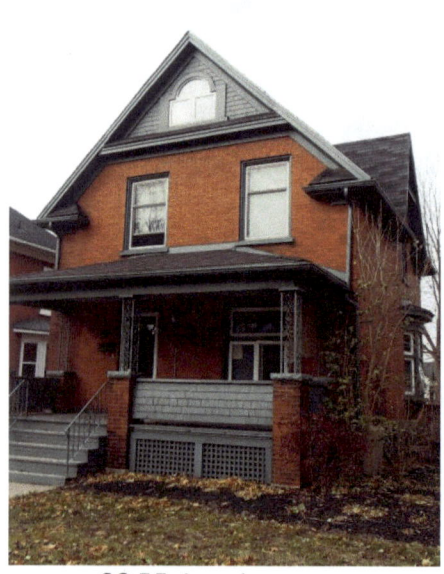

32 Heins Avenue

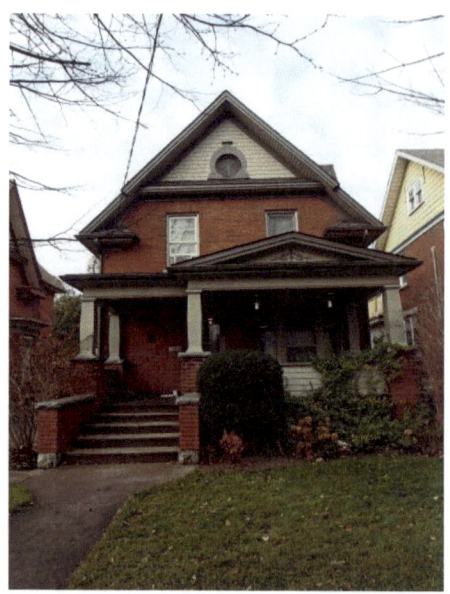

42 Heins Avenue

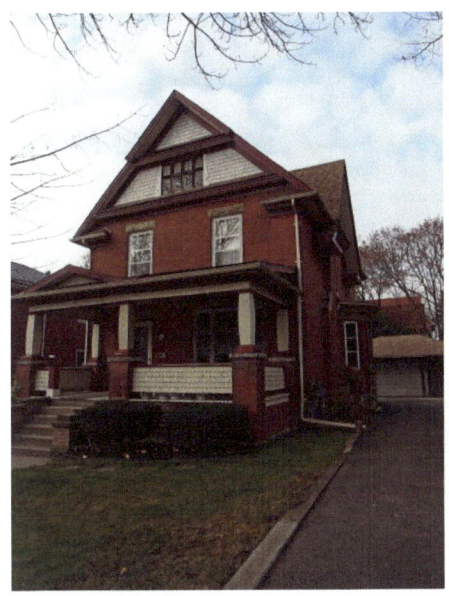
44 Heins Avenue

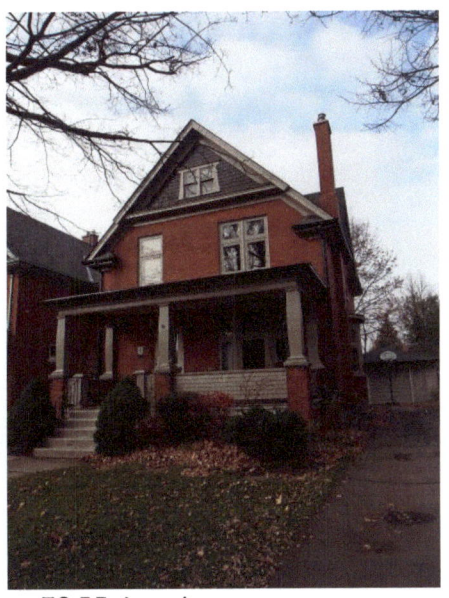
52 Heins Avenue

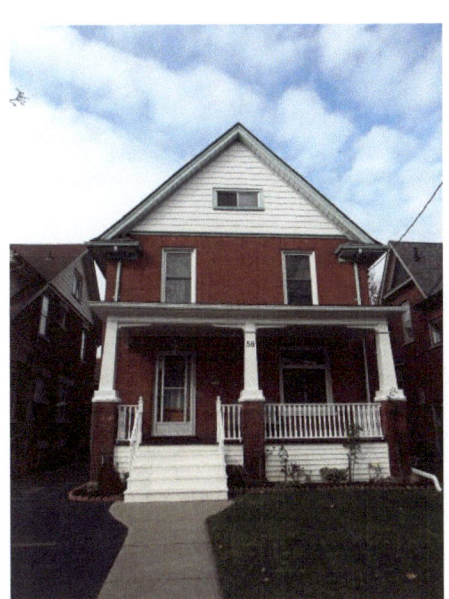
58 Heins Avenue

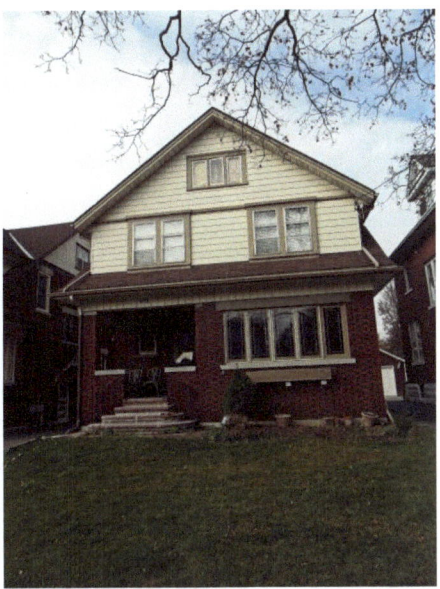
60 Heins Avenue

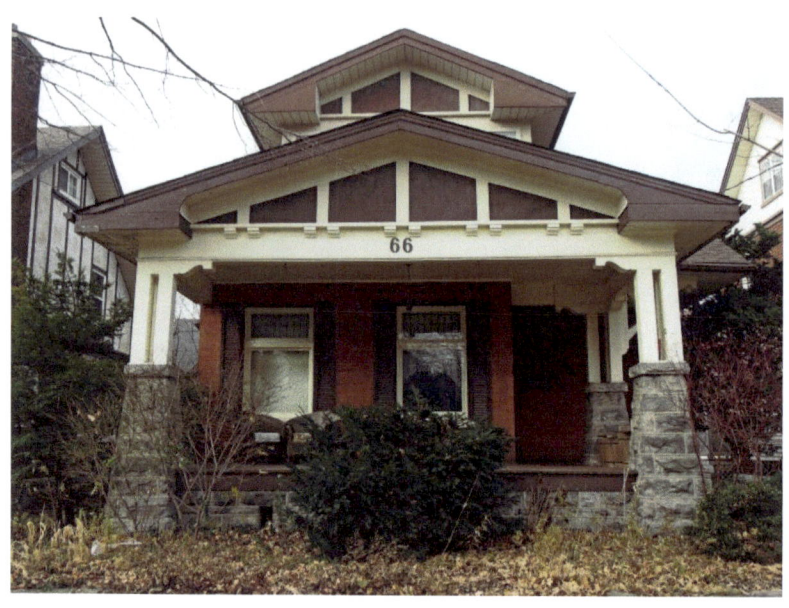

66 Heins Avenue – Gothic Revival with dormer in attic

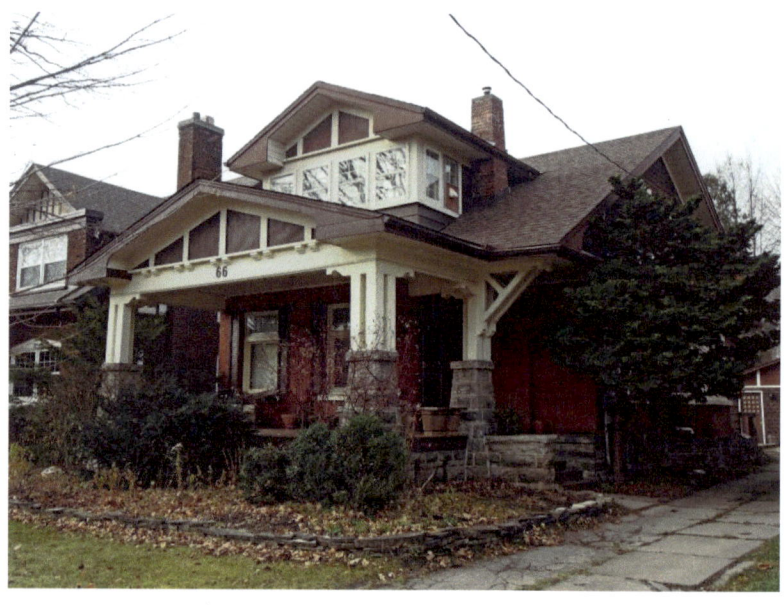

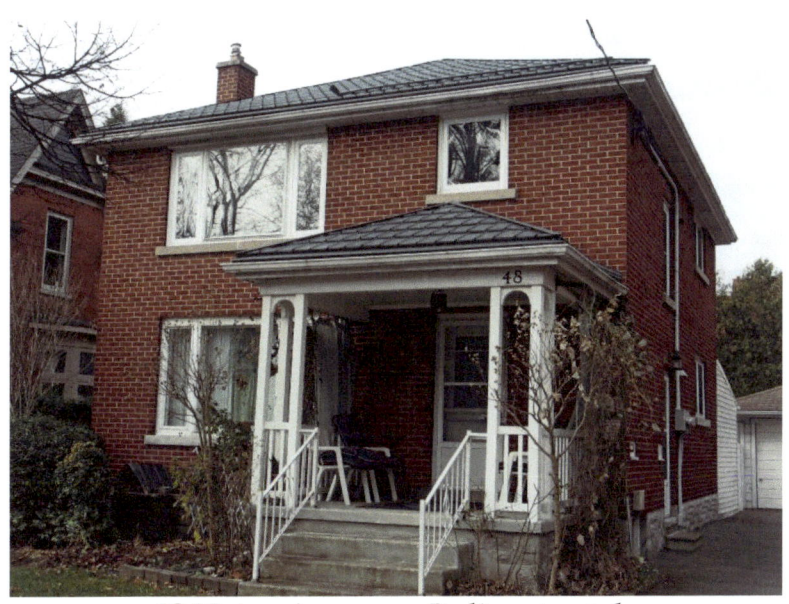
48 Heins Avenue – Italianate style

Reflections

Ducks swimming

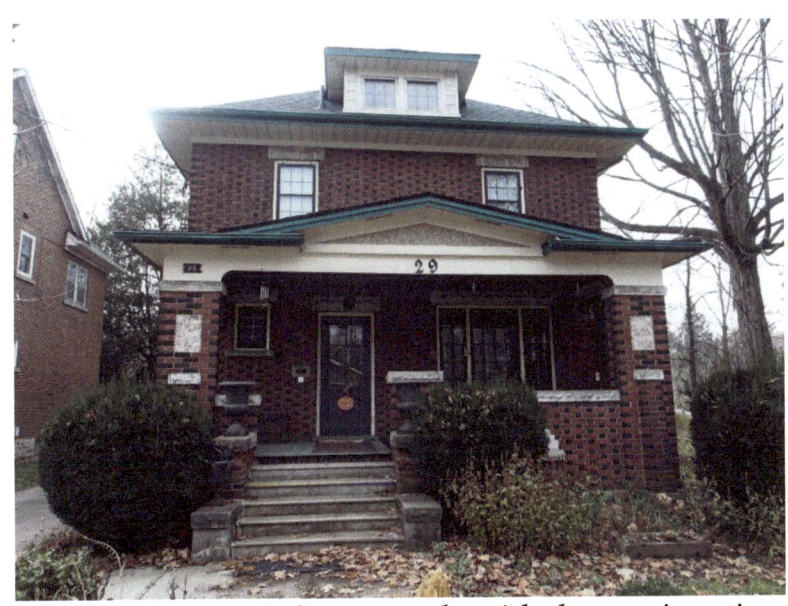

29 Dill Street – Italianate style with dormer in attic

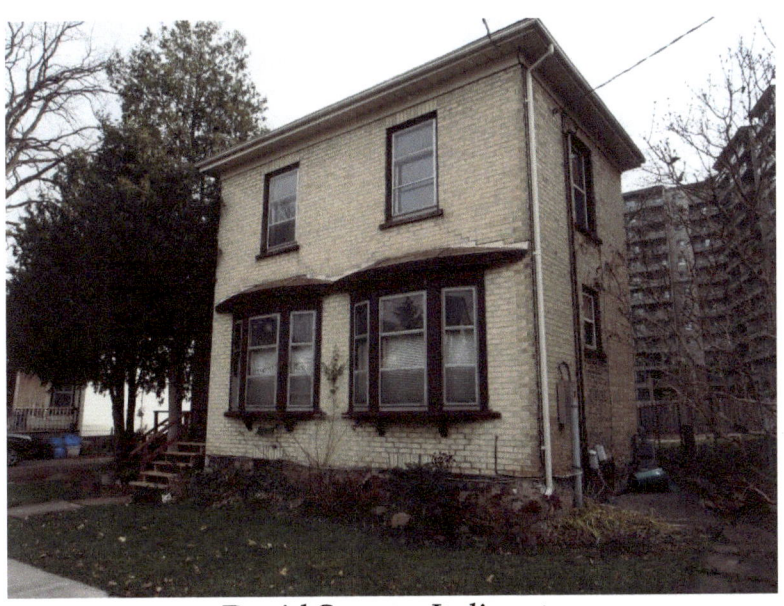

David Street – Italianate

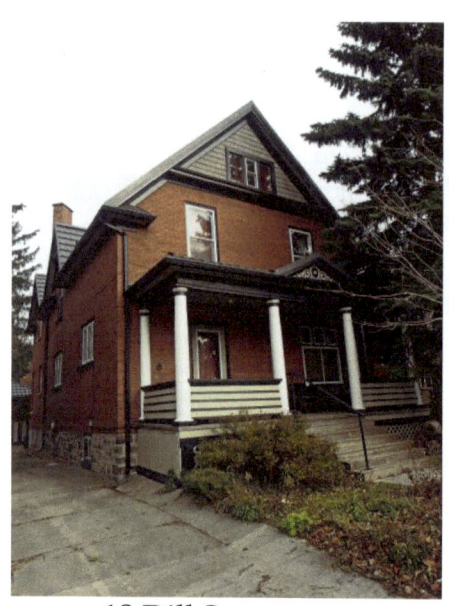 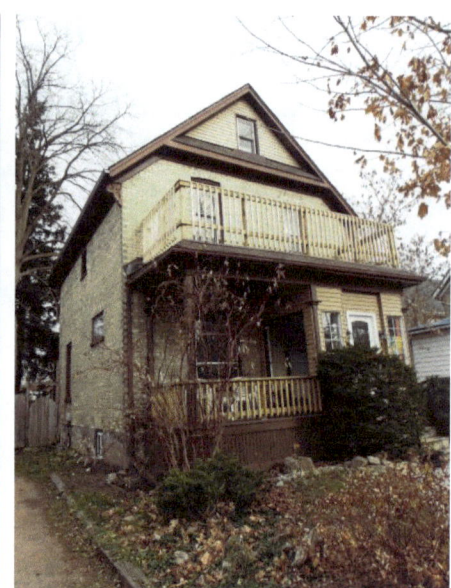

18 Dill Street 8 Dill Street
Edwardian style

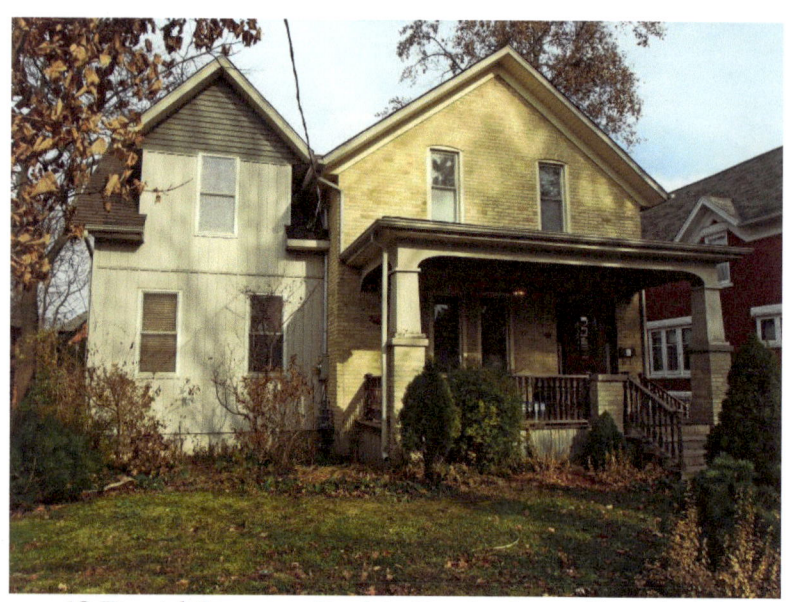

48 David Street – Gothic Revival – yellow brick

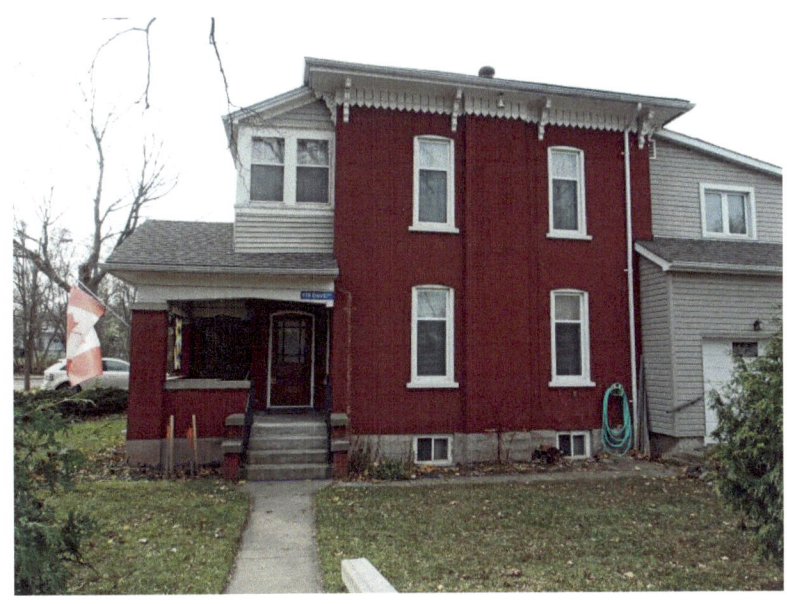

176 David Street – single cornice brackets

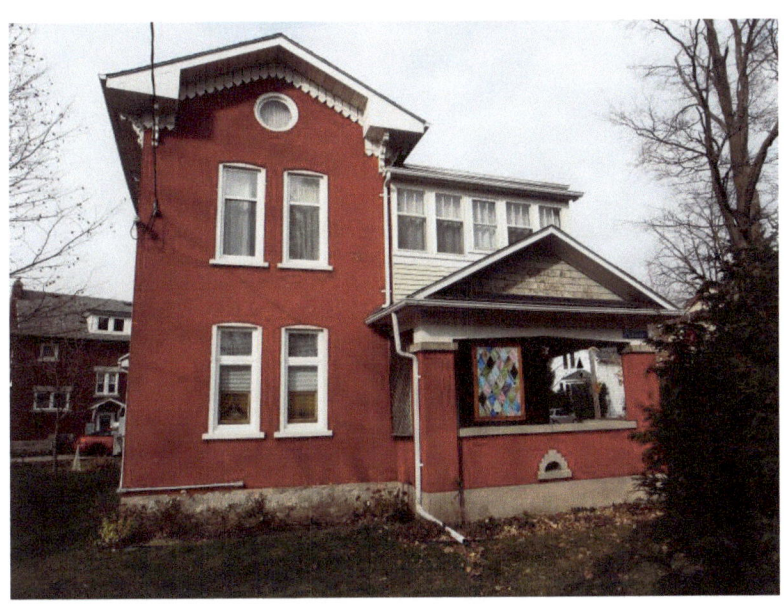

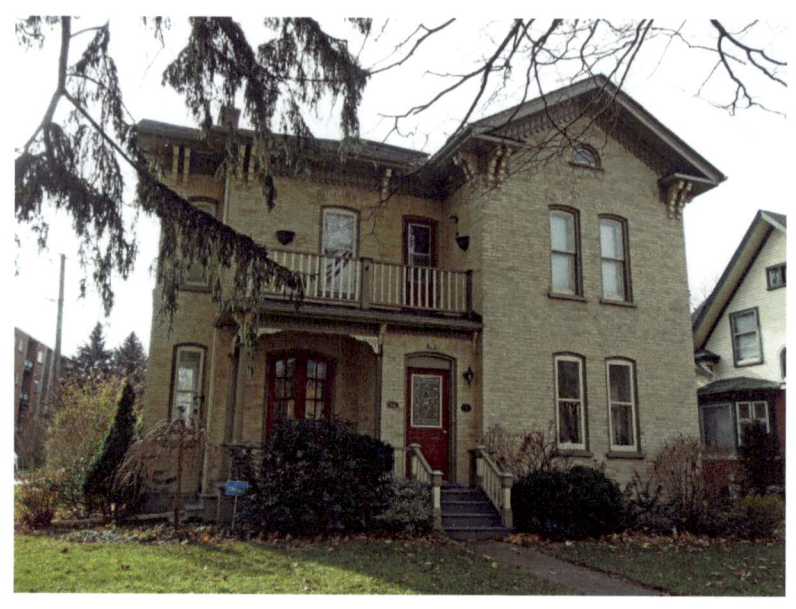

43 David Street – c. 1888 – Italianate with two-and-a-half storey tower-like bay with gable; ornate cornice brackets – yellow brick

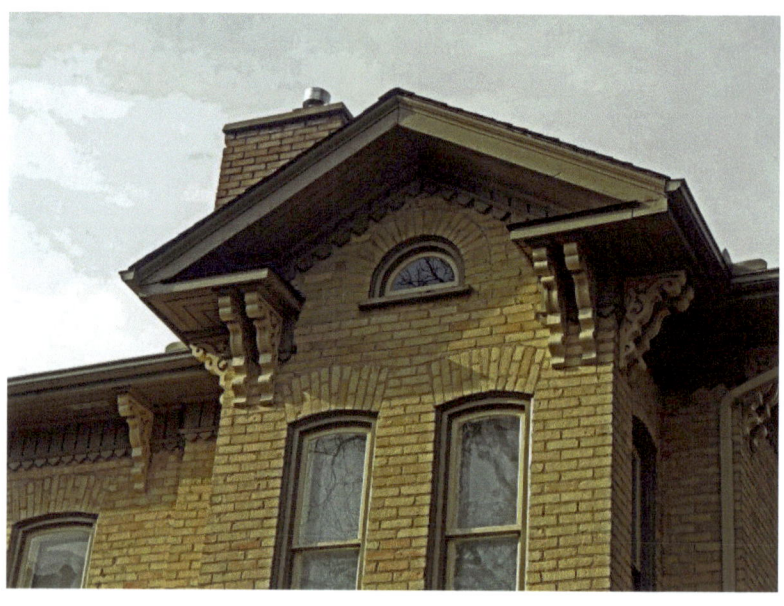

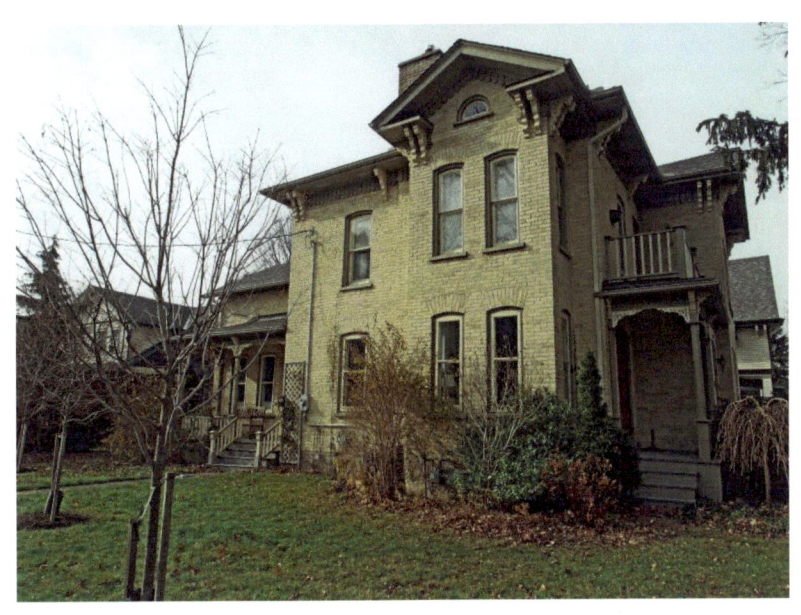

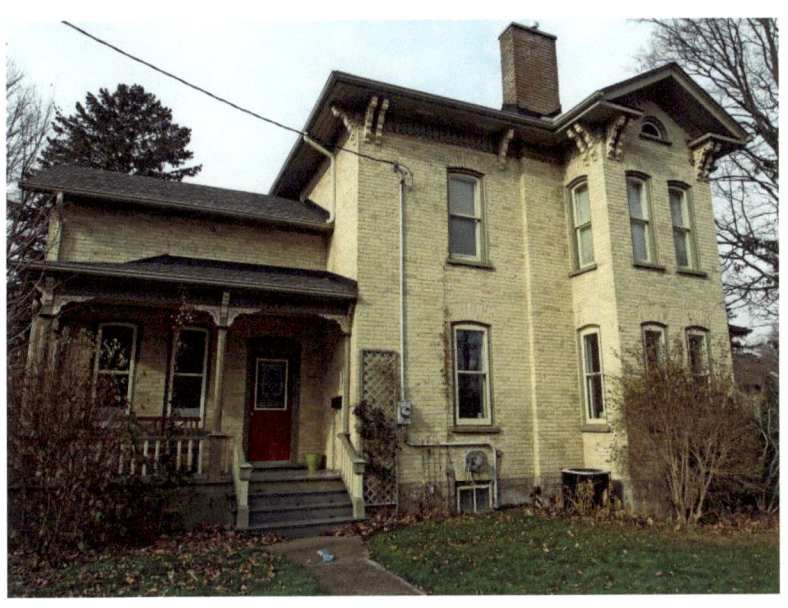

David Street
Edwardian – cornice brackets under cornice return

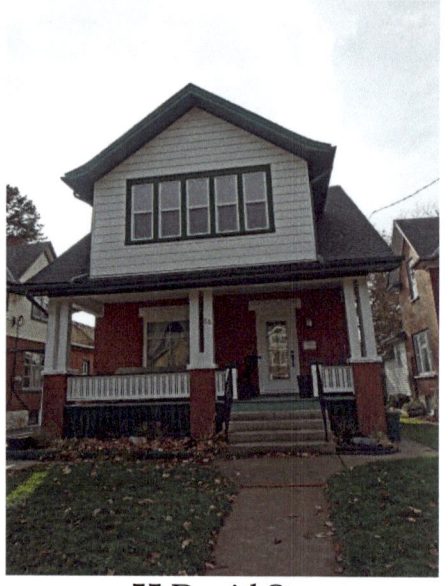

55 David Street

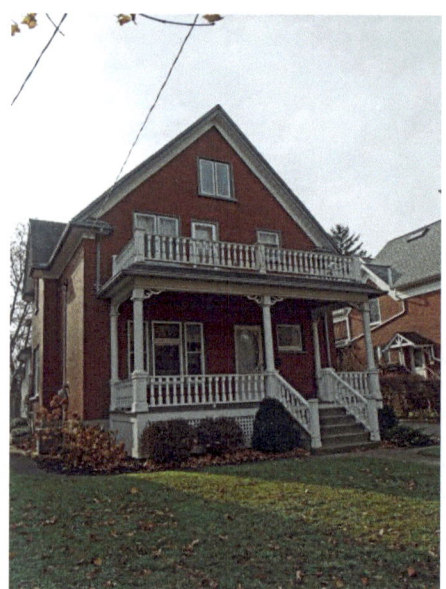

David Street

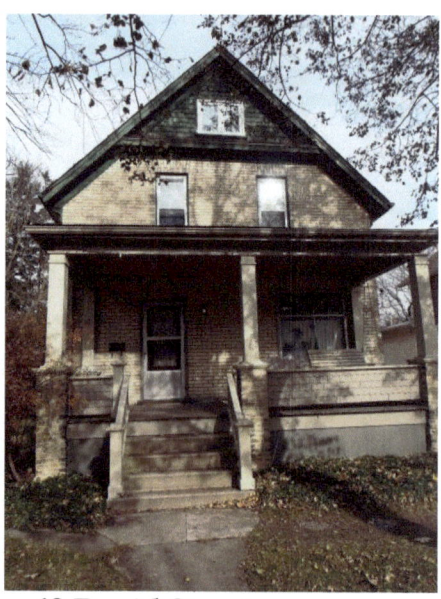

60 David Street

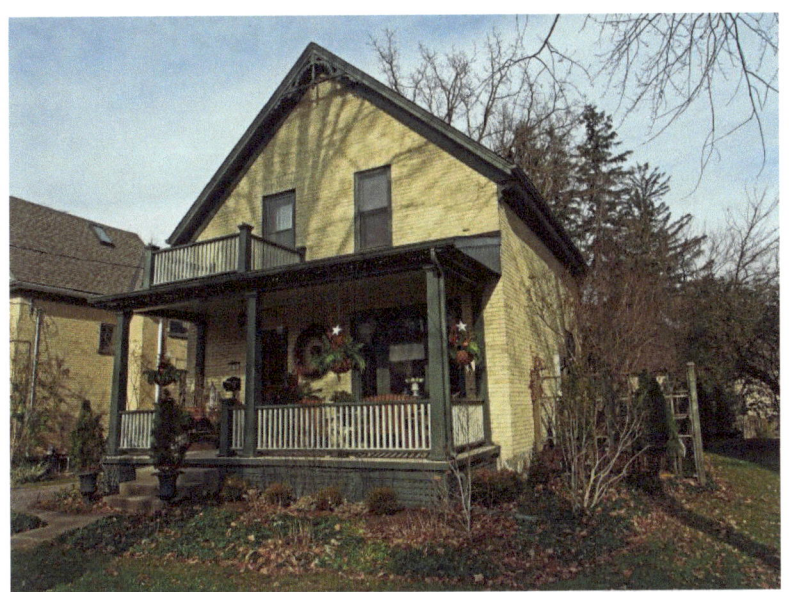

64 David Street – Gothic Revival – yellow brick

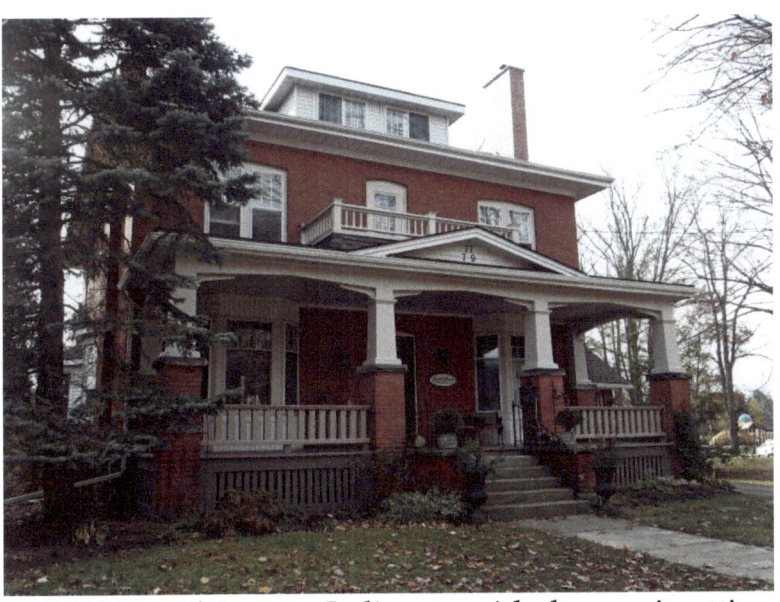

77, 79 David Street – Italianate with dormer in attic

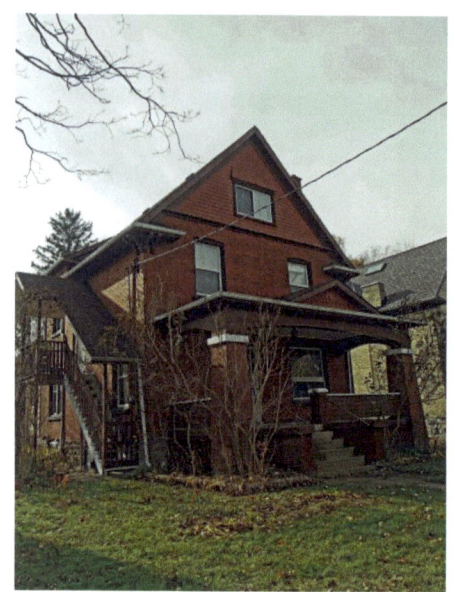
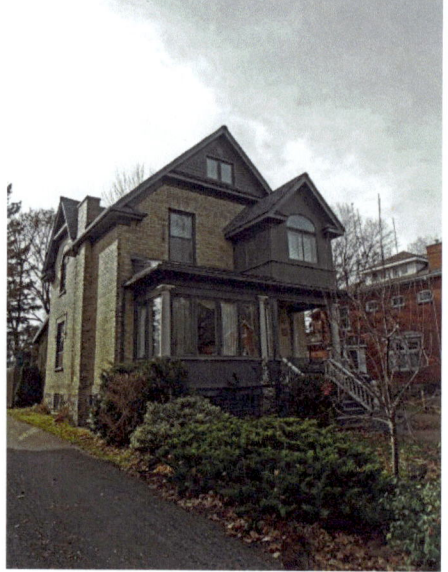

67 David Street 71 David Street
Edwardian style

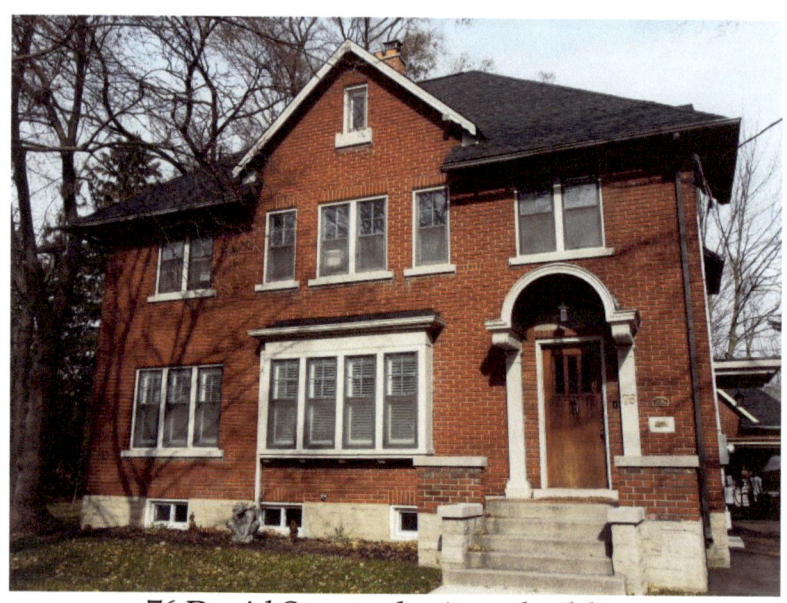

76 David Street – heritage building

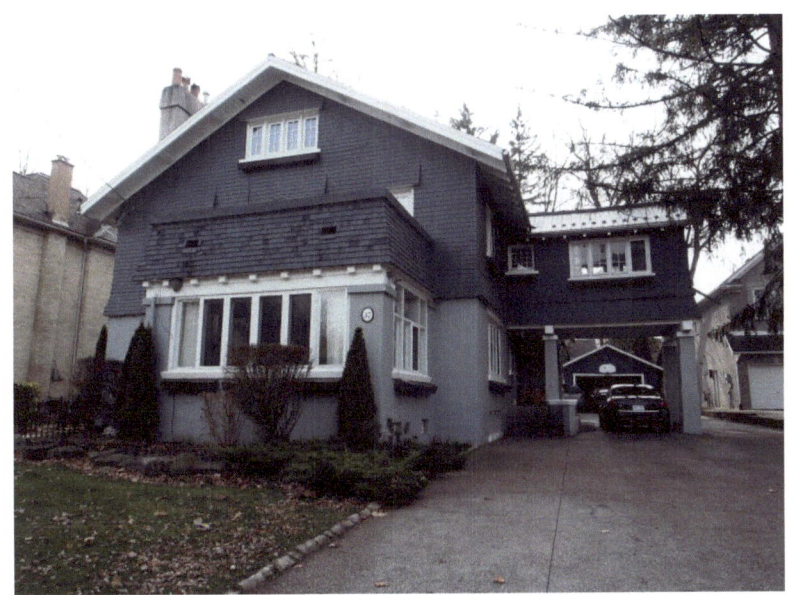

37 David Street

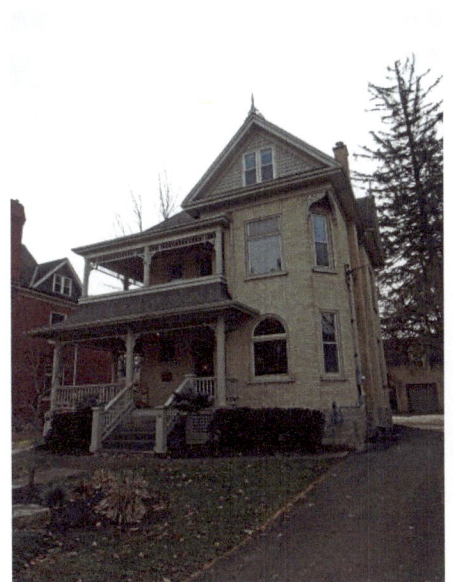

33 David Street

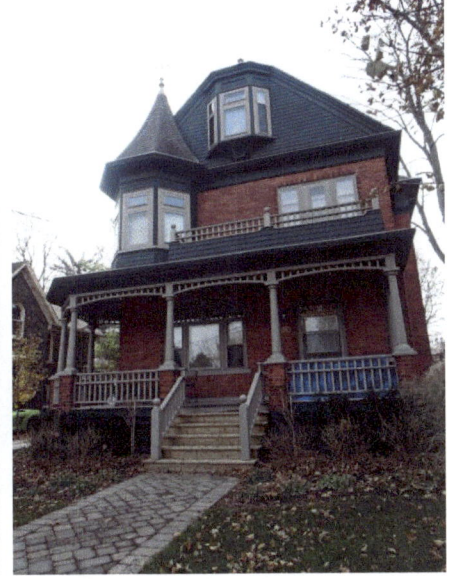

23 David Street
Turret on second floor,
dormer in attic

David Street 19 David Street

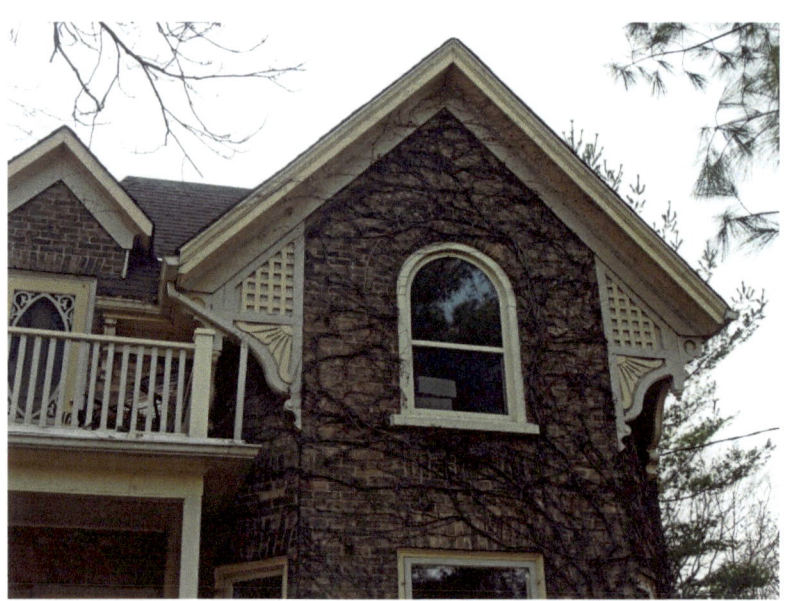

Fretwork pieces resembling brackets

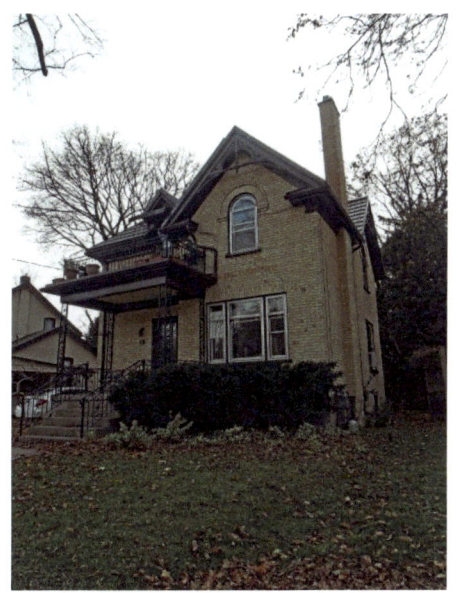

15 David Street – Gothic Revival – Vergeboard trim on gable, yellow brick

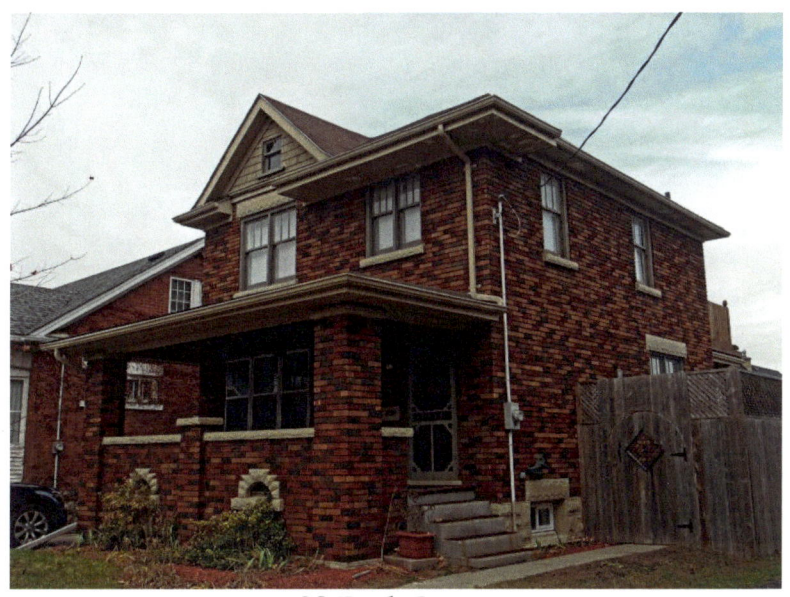

22 Park Street

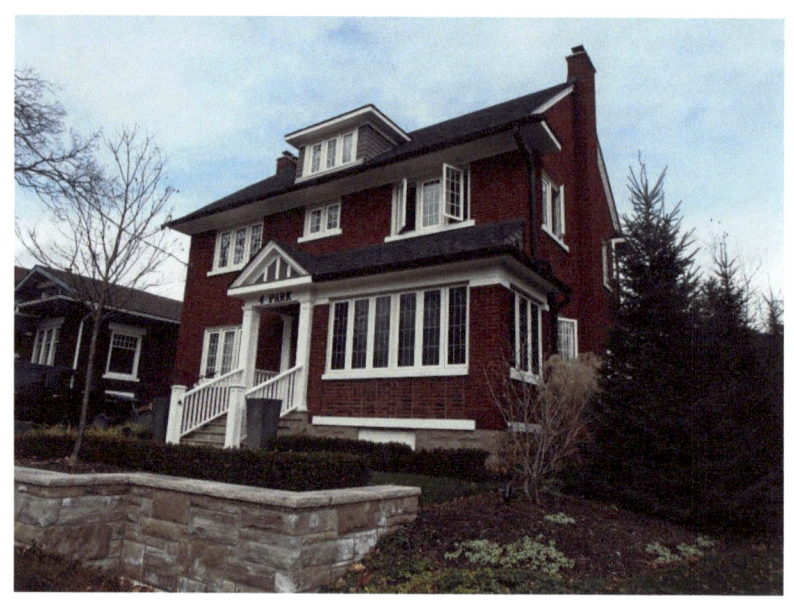

4 Park Street – Georgian like, dormer in attic

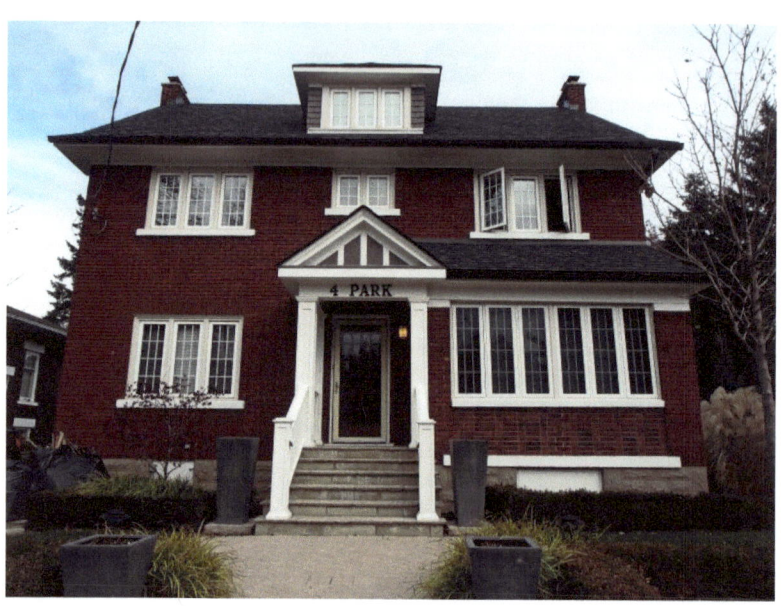

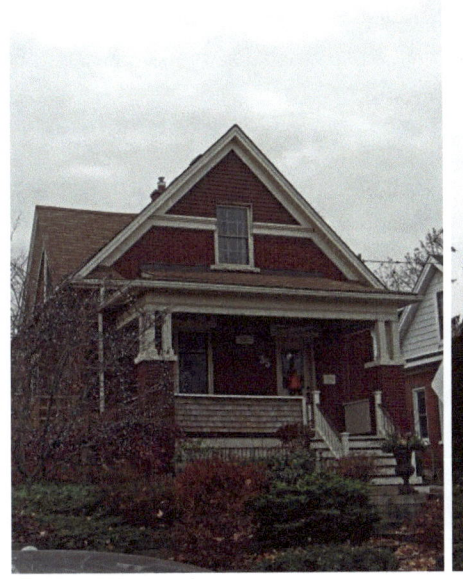

35 Park Street
Gothic Revival

55 Park Street

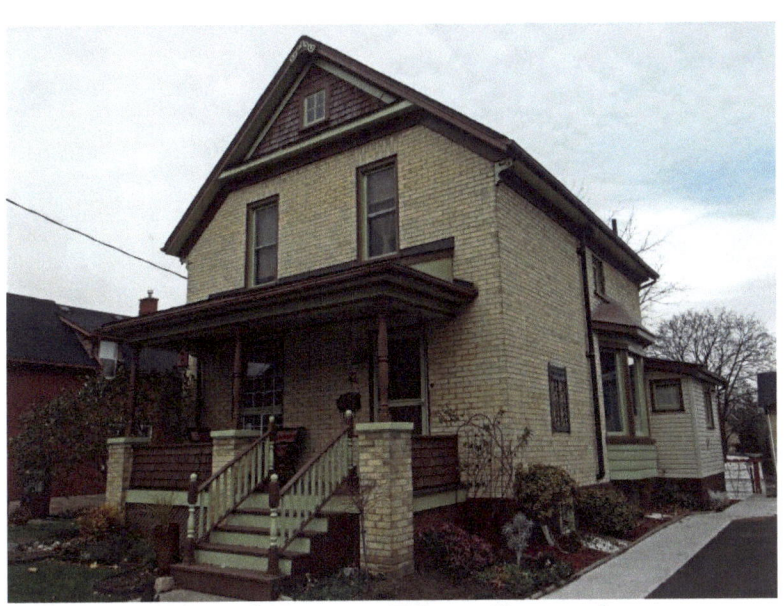

42 Park Street – Edwardian style

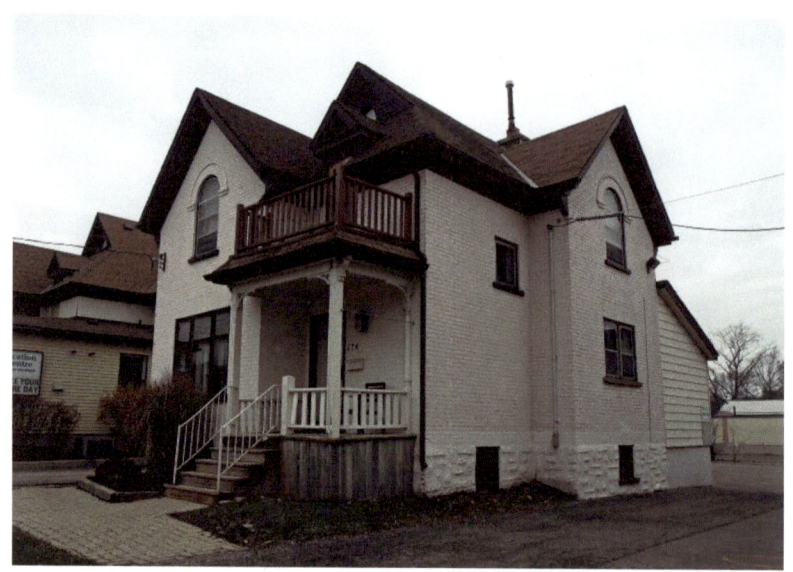

174 Park Street

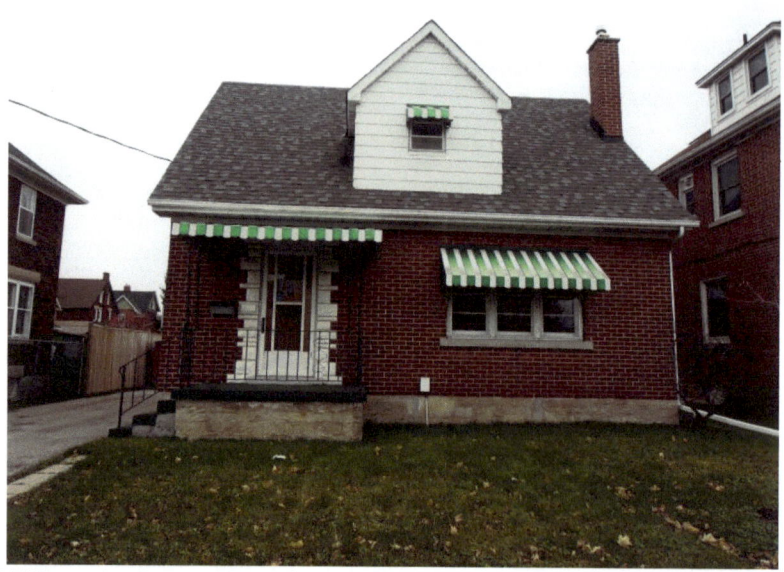

179 Victoria Street South – one-storey cottage, dormer in attic

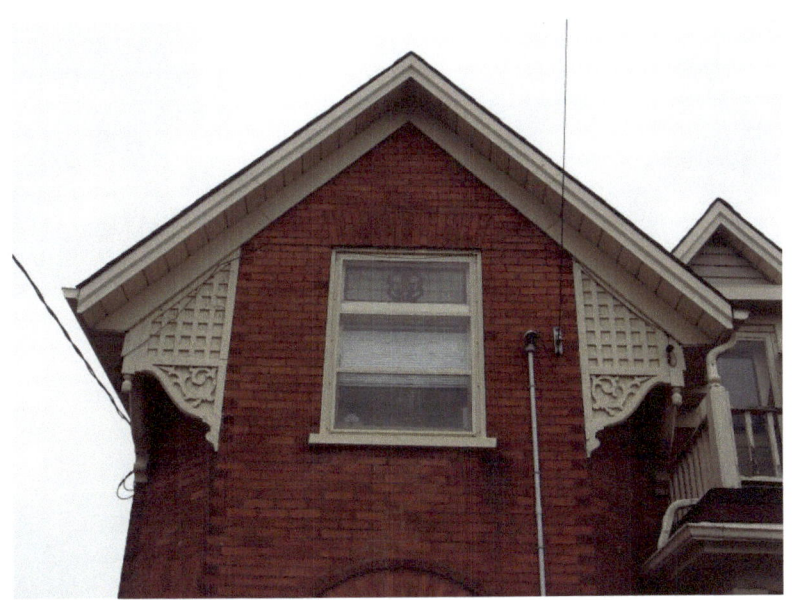

Fretwork pieces resembling brackets
182 Victoria Street South

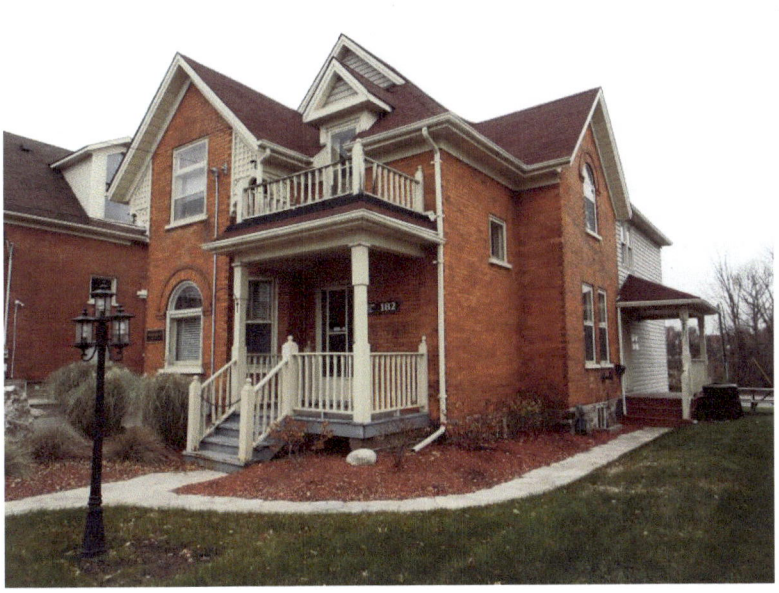

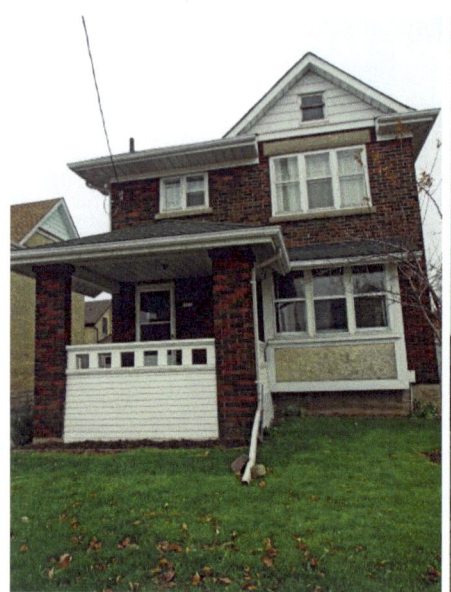
177 Victoria Street South

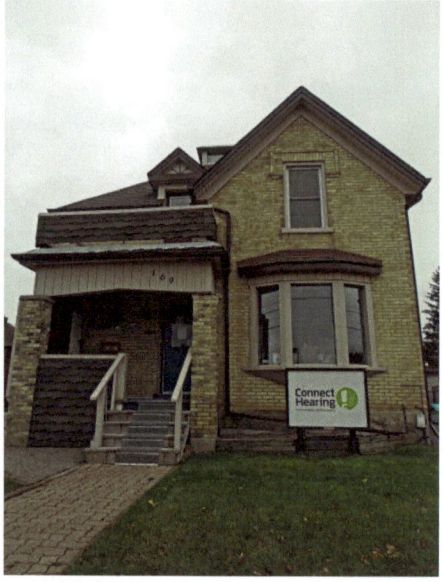
169 Victoria Street South
Yellow brick, decorative window hood, attic dormer

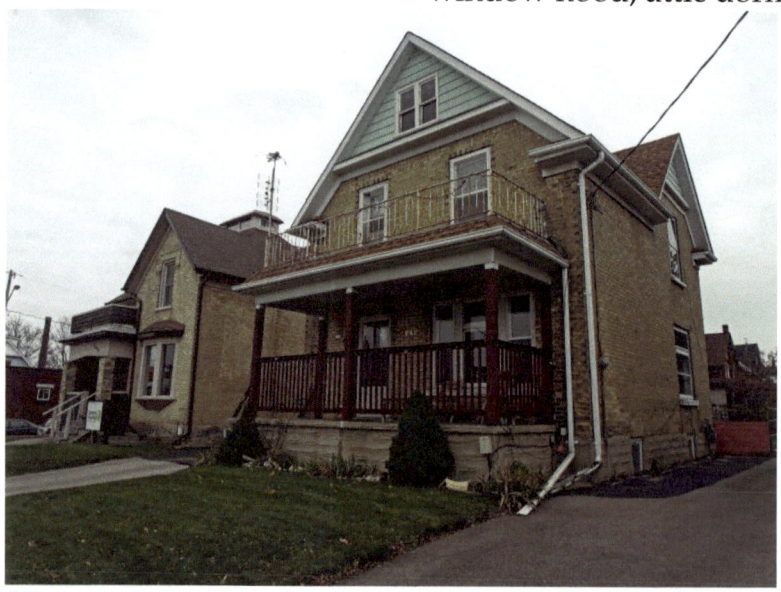
173 Victoria Street South – Edwardian – yellow brick, balcony above verandah

155 Victoria Street South
Gothic Revival

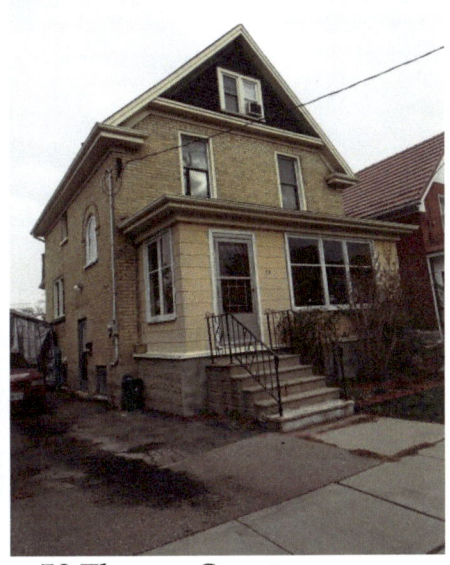

50 Theresa Street
Edwardian – yellow brick

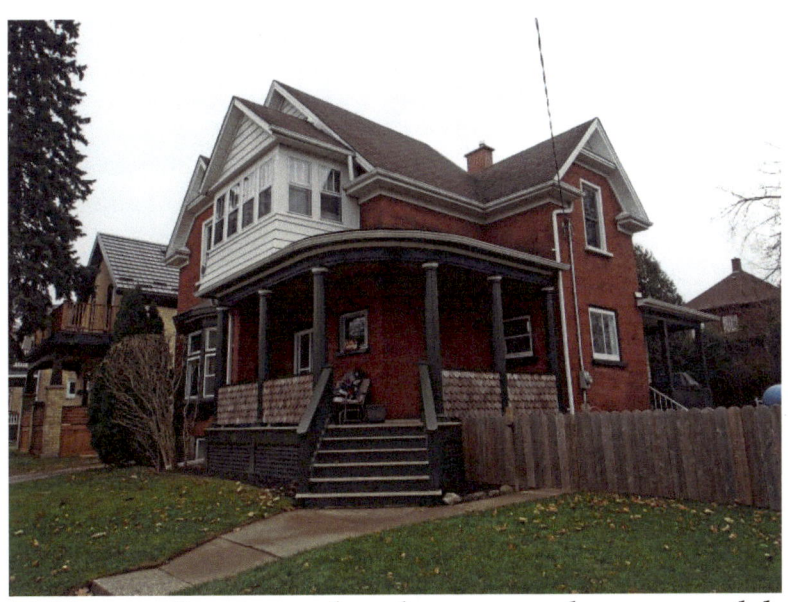

51 Theresa Street – enclosed sunroom above verandah

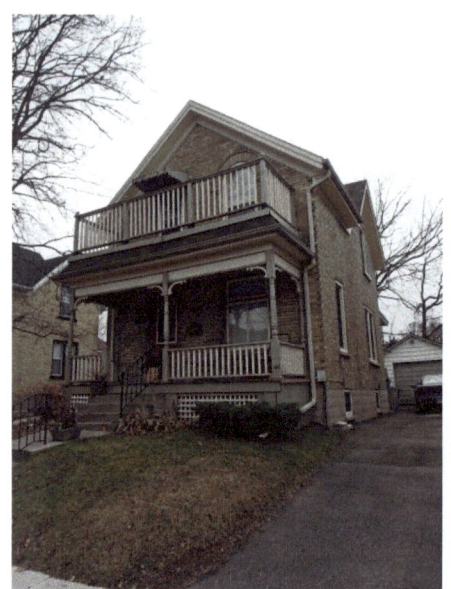

39 Theresa Street
Gothic Revival

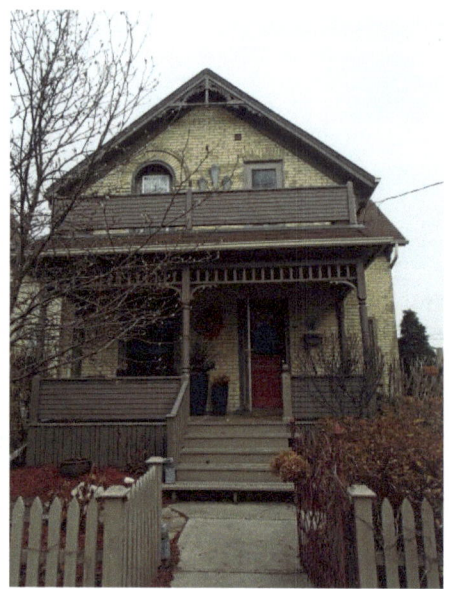

38 Theresa Street
Vergeboard trim on gable

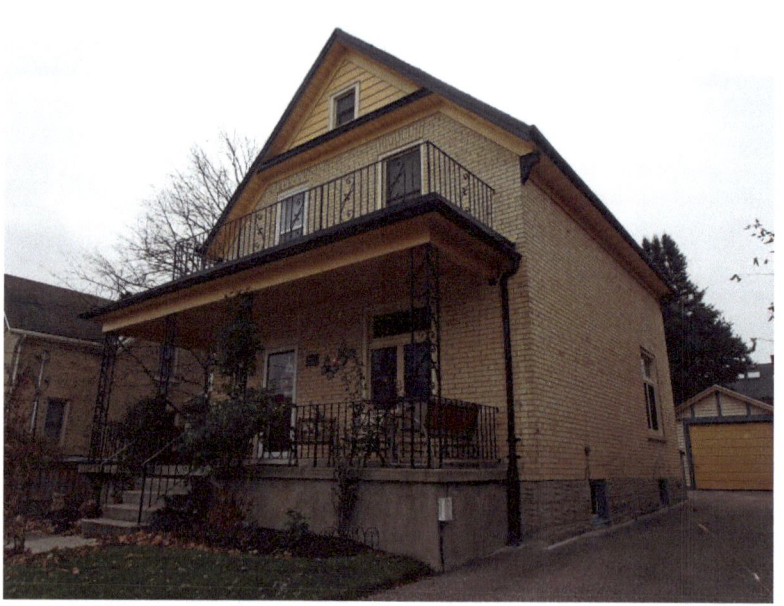

27 Theresa Street – yellow brick – Edwardian

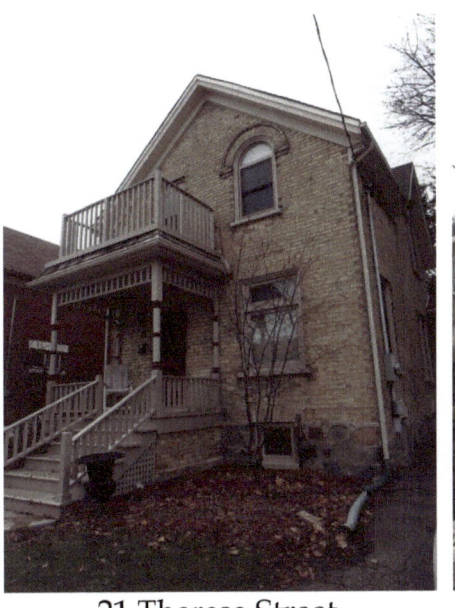
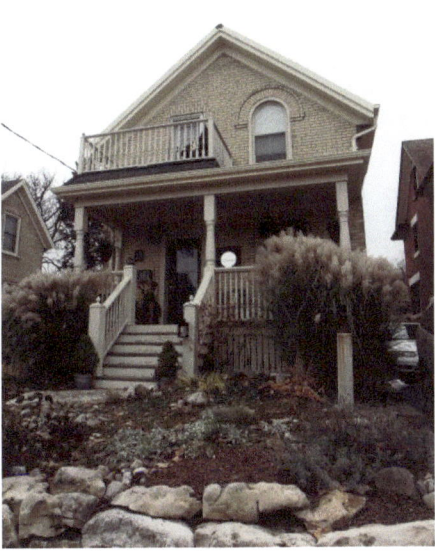

21 Theresa Street 15 Theresa Street
Gothic Revival – arched window voussoirs, balcony above
Cobblestone basement

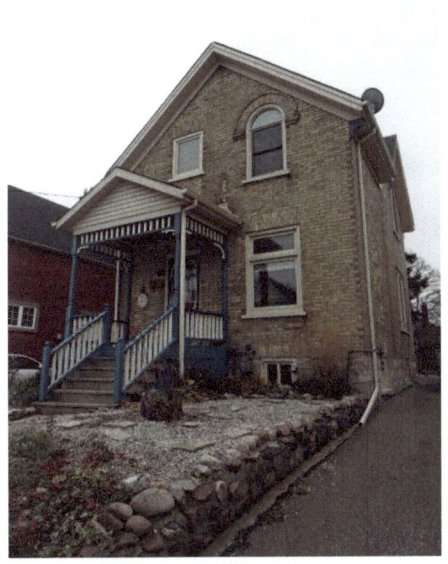
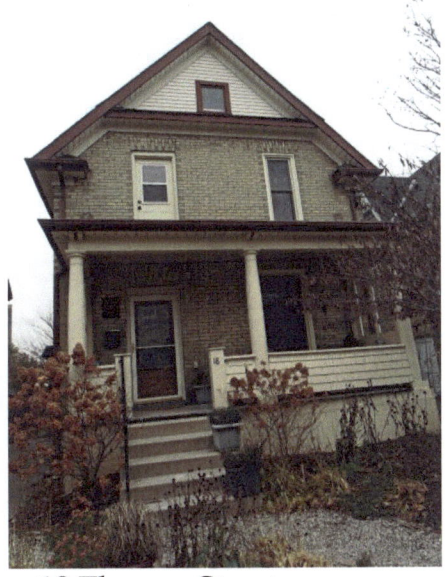

Theresa Street 18 Theresa Street
Gothic Revival Edwardian style
 Yellow brick

Architectural Terms

Brackets: a decorative or weight-bearing structural element which forms a right angle with one side against a wall and the other under a projecting surface such as an eave or roof. Example: 93, 95 Water Street South	
Cobblestone architecture: Refers to the use of cobblestones embedded in mortar as a method for erecting walls on houses and commercial buildings. Example: 82 Heins Avenue	
Cornice: originally the wooden overhang of the roof. With the use of stone, brick, iron and steel, the cornice is any projecting shelf at the top of a ceiling or roof. They can be very decorative. Example: 176 David Street	
Cornice Return: decorative element on the end of a gable. Example: 43 David Street	
Dormer: (French for "sleep") a gable end window that pierces through the plane of a sloping roof surface to create usable space in the top floor or attic of a building by adding headroom. Example: 73 Heins Avenue	
Finial: ornament added to the top of a gable, pinnacle, canopy or spire – a Gothic element. Example: 33 David Street	

Fretwork: interlaced decorative design resembling a bracket Example: 113 Water Street South	
Gable: the triangular portion of a wall between the edges of a sloping roof. Example: 212 Wellington Street North	
Hipped Roof: a roof where all sides slope downwards to the walls with no gables. Example: 82 Heins Avenue	
Keystones and Voussoirs: a voussoir is a wedge-shaped element used in building an arch. A keystone is the central stone that locks all the stones into position, allowing the arch to bear weight. A keystone is often enlarged and embellished. Example of Voussoir: David Street	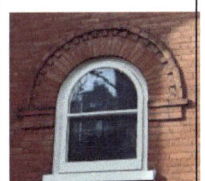
Palladian Window: a large window that is divided into three sections with the centre section larger than the two side sections and usually arched. Example: 49 Heins Avenue	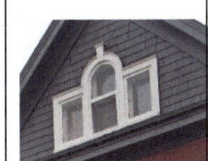
Pediment: a triangular section above the horizontal structure (entablature), typically supported by columns. The inside of the triangle is called the tympanum. Example: 41 Heins Avenue	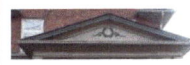

Turret: a small tower that projects from the wall of a building. Example: 23 David Street	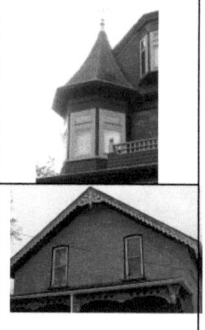
Vergeboards: also called bargeboards (gingerbread) – hang from the projecting end of a roof and are often elaborately carved and ornamented. Example: 21 Ahrens Avenue	

Kitchener's Building Styles

Edwardian, 1900-1930 – This style bridges the ornate and elaborate styles of the Victorian era and the simplified styles of the 20th century. Balanced facades, simple roof lines, dormer windows, large front porches, and smooth brick surfaces are its characteristics. Example: 138 Water Street South	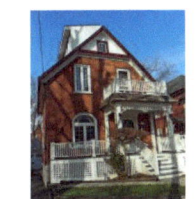
Georgian, before 1860 – This style began with the British King Georges in the 18th century. These buildings have balanced facades around a central door, medium-pitched gable roofs, and small paned windows. Example: 4 Park Street	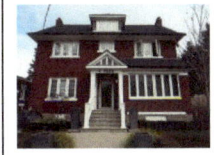
Gothic Revival, 1830-1890 – These decorative buildings have sharply-pitched gables with highly detailed vergeboards, pointed-arch window openings, and dichromatic brickwork. It is a common style in Ontario. Example: Water Street South	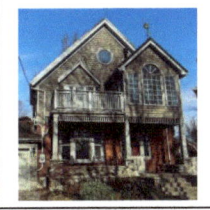
Italianate, 1850-1900 – It has wide-bracketed eaves, belvederes, wrap-around verandahs. Example: 29 Dill Street	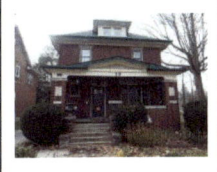

Queen Anne, 1885-1900 – This style is distinguished by an irregular outline featuring a combination of an offset tower, broad gables, projecting two-storey bays, verandahs, multi-sloped roofs, and tall, decorative chimneys. A mixture of brick and wood is common. Windows often have one large single-paned bottom sash and small panes in the upper sash. Example: 120 Water Street South	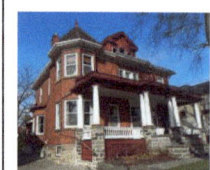
Regency Cottage, 1830-1860 – This style originated in England in 1815 and spread to Ontario later in the 19th century as British officers retired to Canada. It is a modest one-storey house with a low-pitched hip roof and has a symmetrical front façade. Example: 179 Victoria Street South	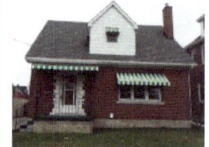

www.ingramcontent.com/pod-product-compliance
Lightning Source LLC
Chambersburg PA
CBHW040855180526
45159CB00001B/432